Journal of
MEDIA ECONOMICS

Volume 16, Number 2 2003

SPECIAL ISSUE ON THE CHANGING WORLD OF PUBLISHING

CONTRIBUTORS

Sarah Maxwell is an assistant professor in the Department of Marketing and co-director of the Pricing Center at Fordham University's Graduate School of Business Administration, New York, NY 10023.

Laura J. Miller is an assistant professor in the Department of Sociology at Brandeis University, Waltham, MA 02454.

Mary Alice Shaver is professor and chair of the Department of Advertising at Michigan State University, East Lansing, MI 44824.

Dan Shaver is an assistant professor in the Department of Journalism at Michigan State University, East Lansing, MI 44824.

Richard van der Wurff is an associate professor at the Amsterdam School of Communications Research at the University of Amsterdam, Kloveniersburgwal 48, 1012 CX Amsterdam, The Netherlands.

JOURNAL OF MEDIA ECONOMICS, *16*(2), 71–86

Books and Digital Technology: A New Industry Model

Dan Shaver

School of Journalism
Michigan State University

Mary Alice Shaver

Department of Advertising
Michigan State University

Adoption theory analysis of the e-publishing industry indicates that consumer acceptance of current technology is the greatest barrier to attaining a critical consumer mass. New electronic paper technologies will soon offer a superior consumer alternative. Publishers will be faced with new opportunities and nagging issues related to new competition, content control, and protection of revenue streams requiring strategies that stress rationalization of distribution systems, cross-promotion, strategic pricing, and leveraging of new revenue sources—particularly advertising.

The economics of book publishing have changed little in the half-millennium since Gutenberg. Authors create content and publishers transform that content into manufactured products. Readers purchase books, providing resources to reward both the publisher and the author. The rise of mass media in the last century brought changes in marketing and promotion; digital technologies have brought increased efficiencies to the manufacturing and distribution processes. Industry consolidation has modified the competitive environment, however, the core economic model remains essentially the same.

Despite a great deal of discussion in the popular press, e-books—digitally based content—have failed to attain little more than curiosity status and appear to represent little immediate threat to the existing book publishing model (Baker, 2000). Indeed, a survey of computer-literate and regular readers conducted in August/September 2001 found that only two thirds of the respondents had heard of e-books (Guthrie, 2002). The purpose of this study is to examine the relative lack of success of e-pub-

Requests for reprints should be sent to Dan Shaver, School of Journalism, Michigan State University, East Lansing, MI 44824. E-mail: shaverd@msu.edu

lishing through the lens of adoption theory in the belief that such an analysis will not only explain past failures but will also reveal how the utilization of new technologies can create a new economic publishing model with the potential to supplant large segments of the existing industry in the next several decades.

It should be noted that this analysis applies principally to the United States and other technologically sophisticated markets. Even within these markets, significant niches will likely remain best suited for print for the foreseeable future.

SIGNIFICANT CHARACTERISTICS OF INNOVATIONS

Researchers have applied a variety of conceptual categories to the description of successful innovations, but one of the simplest and most analytically useful is the five-characteristic structure proposed by Rogers (1962)—relative advantage, compatibility, communicability, complexity, and divisibility. Meta-analysis of these characteristics indicates that relative advantage, compatibility, and communicability have the strongest correlation with adopters' perceptions of new technology (Parker, 1996). Our analysis will focus primarily on these three dimensions.

Relative advantage is defined in terms of the perceived superiority of an innovation to the product or idea that it replaces. The advantages may be measured in economic or other terms, but it is the perception of the degree of advantage that is most important in determining adoptability (Rogers, 1962, pp. 125–126). Compatibility is measured by how congruent the innovation is with the assumptions, experiences, and values of adopters (Rogers, pp. 126–129). Other researchers, for example, have found support for the idea that people are more likely to adopt information technologies that operate in ways that are similar to the technologies with which they are already familiar (LaRose & Atkin, 1992).

Communicability is a measure of the ease with which the results and advantages of an innovation can be transmitted or diffused to others. The advantages and operations of some innovations are fairly easy to communicate within a social group; the characteristics of others are more obscure. The clearer and easier the communication process, the more likely adoption is to occur by others in the group. (Rogers, 1962, p. 132)

The last two dimensions, complexity and divisibility, appear to have less relevance to our analysis. Indeed, complexity, which Rogers (1962) defined as "the degree to which an innovation is relatively difficult to understand and use" (p. 130), might easily be viewed as an interactive function of compatibility and communicability. Divisibility, the ability to try an innovation on a limited basis (Rogers, 1962, p. 131), is almost by definition a characteristic of e-publishing. Adopters can easily utilize both paper and electronic publishing techniques and products simultaneously.

Of course, the characteristics that lend an innovation to adoption represent only one side of traditional adoption and diffusion theory. The other portion of the theory deals with the characteristics of who adopts innovations and when they adopt.

For purposes of this analysis, however, we will focus on the characteristics of the innovation—or product—that appear to make it more or less suited for general adoption over a period of time rather than on defining the sequence in which social segments are most likely to adopt.

A SHORT HISTORY OF E-PUBLISHING

Electronic publishing initiatives began in the early 1990s with companies like Voyager and Vertigo Development that offered books on CD-ROM for consumption on desktop computers (Maxwell, 2000), and organizations like Bartleby.com and Project Gutenberg that specialized in digitizing the text of classics which had fallen into the public domain and making them available for downloading via the Internet (O'Leary, 2000). Then, in 1992, Sony brought to market the first dedicated "reader," the Sony Bookman, sometimes called "a brick with a screen" (Lardner, 1999).

By the end of the 1990s, things looked promising for e-publishing. NuvoMedia's Rocket eBook hit the stores in 1998 and was quickly followed by SoftBooks Press' SoftBook, the EveryBook, and software that allowed the downloading and reading of book text on Palm and other personal digital assistants. The price of readers was dropping and, in 1999, Microsoft affiliated itself with a group of 75 publishers to define a technical open standard that would permit book files to be read on multiple platforms—desktop computers, a variety of portable, dedicated reading devices, and handheld computers (Maxwell, 2000). In March 2000, the Association of American Publishers met to consider the future of e-publishing. They heard a report from Andersen Consulting that recommended industry-wide adoption of an open standard, predicted that the number of reading devices in the hands of consumers would increase from 30,000 to 28 million by 2005, and predicted a consumer market for e-books of between $2.3 billion and $3.4 billion within five years (Milliot, 2000a).

Also in March 2000, Stephen King e-published *Riding the Bullet*, a 66-page story that was his first work after recovering from a near-fatal car accident. The site experienced 400,000 downloads the first day it was online (Castelluccio, 2000). There was one dark side to King's experiment, however. He asked that downloaders voluntarily pay $1 per chapter. He hoped that 75% of his readers would pay up under an honor system. When only about 50% of readers complied, he suspended the experiment (Jantz, 2001).

About 300 people attended Electronic Book 2001 in Washington, D.C., November 5–7, 2001. The fourth annual meeting hosted by the U.S. Department of Commerce's National Institute of Standards and Technology and the National Information Standards Organization (an industry association of publishing, library, and information technology representatives) heard Simon & Schuster president and chief operating officer Jack Romanos assert "the e-publishing revolution is right on schedule" despite overly optimistic market predictions (Lichtenberg,

2001). At the same meeting, a panel of venture capital executives said that despite the downturn, financing was still available for e-publishing ventures with business models offering demonstrable profitability. Microsoft was not represented at the conference.

The bloom quickly faded, however. By November/December 2001, a number of potentially major players who had jumped quickly into the business were just as rapidly exiting due to the recession and disappointing operating results. TimeWarner announced plans to close IPublish.com, and Mighty-Words.com announced it would close shop (Reid, 2001a). Random House announced it was pulling the plug on AtRandom, and Princeton University Press announced the end of an e-publishing program that had begun less than a year earlier (Rogers & Roncevic, 2002).

A number of issues continue to plague the infant industry. They include issues of full compatibility and open standards, copyright and content control, limited content offering, and hardware quality, as well as questions about pricing and the economic impact of e-publishing on the core print businesses of major publishing houses. Adoption rates remain low. The primary question now is: How can publishers jump-start e-publishing?

IDENTIFYING NECESSARY ADOPTERS

To succeed in the current marketplace, the e-publishing concept requires adoption by multiple, interrelated constituencies. Identifying these constituencies and assessing the degree to which current products or systems may appeal to or conflict with perceived self-interest and values offer clues to the conditions required for successful adoption.

Authors

Writers provide content—words and ideas. In return, they receive financial compensation that is at least theoretically related to the reception accorded their words and ideas by consumers. In many cases, they also receive social or psychological benefits from acceptance of their work. For authors to adopt e-publishing, the principles of relative advantage and compatibility are most important. Any content distribution system that increases the authors' audience size while protecting or increasing their financial and psychological rewards is likely to be embraced. Equally significantly, writers might be drawn to adoption of e-publishing as an alternative to traditional print publishing—particularly if their works have been rejected by print outlets. Indeed, as early as 2000, web sites offering self-publishing and royalty-collection services to new and established authors began to appear (Press, 2000).

For authors, however, electronic publishing creates issues related to ownership rights. If electronic books never go out of print, new agreements will be required to determine when rights to the work revert to the author. If distribution by a single publisher is international in scale, domestic and foreign rights to the work become inseparable.

Publishers

The front-end processes of editing and packaging a book are little affected by the delivery channel used. The manufacturing process, however, differs dramatically. The principle of relative advantage offers a complex choice for would-be e-publishers.

Positive advantages include decreased manufacturing expense. Digital delivery requires no paper, no presses, no binders, no shipping. One early online publisher, Futurebook, claimed to be able to reduce the cost of a book by 75% ($6 vs. $24) while maintaining royalty levels for authors (Schuyler, 1998). Returns, which averaged nearly 24% in the late 1980s, are eliminated (Greco, 1997). Increased flexibility is another advantage of electronic delivery. Inventories, back orders, and out-of-stock situations can be eliminated, freeing capital for investment in new projects. Online delivery provides an instant international delivery channel without the need to develop physical distribution relationships, allowing the development of new markets.

E-publishing also offers the opportunity for unprecedented levels of accuracy and interactivity. Errors and updates can be made immediately and will be reflected in all future copies of the publication. This can be particularly useful for publishers of scholarly materials. In 2001, Princeton University Press briefly experimented with issuing supplemental content for books they would publish both electronically and on paper. The supplemental material would "allow the author to address critics, media attention or any subsequent questions or debate spurred by the book's original publication" (Reid, 2001b). Unfortunately, by the end of 2001, Princeton University Press had cancelled its entire electronic publishing initiative due to the recession.

A number of positive economic advantages are also associated with online delivery. Warehousing, transportation, and the waste expense associated with the fact that more than 30% of published books go unsold will vanish (Schuyler, 1998). Reduced fixed and manufacturing costs could provide quicker profitability and the ability to publish titles with appeal to more limited audiences. Manufacturing and distribution costs, which typically run 10% to 15% of retail price, would be drastically reduced, and discounts to major retailers, which may run as high as 45% of retail, could be eliminated by direct marketing (Eberhard, 1995). Use of credit card payment procedures in connection with online delivery could cut the payment cycle to publishers for sales from months to days (Schuyler, 1998).

There are, however, negatives as well. Current audience sizes are limited, and higher adoption levels are needed to create a critical mass that provides incentives for new hardware and software development and allows economies of scale in manufacturing.

Even more troubling are issues of copyright, fair use, and content control. The copyrights of print volumes have been buttressed by the fact that actually photocopying an entire book involves considerable time and expense and results in an inferior product. It is usually easier and more satisfactory to legally purchase a book than to copy it. Copying electronic content, however, can be quick and simple, and the copy is in every respect the equal of the original. Because publisher revenues are tied to control of content distribution and pirating of digital information in all formats is rampant, publishers are understandably ambivalent about the affect of e-publishing on their core businesses (Isenberg, 2000). Even complex encryption systems can ultimately be evaded, though probably at the cost of violating the Digital Millennium Copyright Act. Concerns that book publishers might face the kinds of problems plaguing the music industry since the advent of MP3 cause cold sweats in the boardroom. Some digital rights management (DRM) schemes involve either encryption codes that prevent printing any of the material—viewed by some as a violation of traditional fair use exceptions to copyright law (Kinsella, 2001)—or limit the number of devices on which the file can be played. The latter approach tends to discourage users because it means that if their reader breaks, they have to purchase a new copy of the book.

Compatibility issues are also mixed for publishers. Publishing organizations have significant organizational and financial investment in the printing process as a delivery system for their product. While digital delivery systems are not incompatible with the business model of producing and delivering content to consumers at the macro level, there is likely to be considerable internal resistance to the inherent conflicts at the micro level. Strong relative advantage arguments may overcome compatibility reservations, but such conflicts may slow willingness to adopt.

Complexity and communicability are unlikely to be significant barriers to adoption by publishers. The e-commerce model, though relatively new, is pretty straightforward, and most publishers are already providing sales of print products online. Finally, e-publishing is clearly a notion that is divisible. Publishers need not dismantle their presses before they know whether digital delivery will succeed.

Distributors

The distribution chain functions at two levels—wholesale and retail. The wholesale level is essentially one of inventory and transportation/distribution. A highly concentrated and profitable business segment, wholesale distributors will face a

significant threat to their business model by the adoption of e-publishing and can be expected to resist it.

Retail distributors—chains, individually owned bookstores, and miscellaneous outlets such as drug stores and airport shops—face a more complex dilemma. For bookstores and other outlets primarily dependent on book revenue, e-publishing under the current economic model could become simply another product line in the same way that many bookstore chains already sell music and audiobooks. Indeed, many book dealers are already offering current e-book technology, so the adoption barriers are quite low at this level. Costs associated with space rental, staffing, warehousing, and transportation would be reduced. However, like the wholesalers, retailers should be expected to resist mass adoption of delivery systems that have the potential to reduce the influence of their role in the supply chain between publishers and consumers because of the potential for increased competition and reduced publisher discounts. It is not a matter of unwillingness to adopt; it is a matter of economic self-interest.

Consumers

Existing e-book technologies offer consumers a number of advantages. They allow the inclusion of additional books without additional weight; they are environmentally friendly because they consume no paper. Full-text search capabilities, automatic linking to electronic dictionaries, and the ability to change the font and size of type—a particular advantage for the visually impaired—are more benefits derived from the digital nature of e-books (Bunnelle, 2000). Online delivery permits virtually instant ordering at any time. The inclusion of sound and multimedia capabilities in readers further expands the list.

Paper books also have advantages over current e-book technology. E-books require two components—hardware and software; traditional books just require a book. The hardware component can be relatively expensive to acquire; costs range from just under $200 to as much as $1,500. Once the hardware is purchased, the consumer must buy software (content) separately. Although content pricing is a topic of considerable debate and disagreement, most major publishers are issuing popular titles at or near the cost of paper editions (Ditlea, 2000). Unlike books, electronic readers are powered by rechargeable batteries with a limited life between charges; if the battery goes dead, the reading material goes away.

But perhaps the most serious disadvantage of current e-publishing technology lies in the quality of the visual display and its impact on readers. A number of studies indicate physical stress issues arise from reading computer displays. The American Optometric Association has identified "Computer Vision Syndrome," or CVS, as being associated with computer use. Symptoms include eyestrain, blurred or double vision, headaches, increased sensitivity to light, dry eyes, and

distorted color vision (Von Stroh, 1993). These symptoms are most likely related to the disparity in the quality of images offered by computers and paper. For example, the image provided by a liquid crystal display (LCD) is generally about 100 dots per inch (dpi) compared to a normal 1,200 dpi for most printed books. Similarly, computer screen images generally have a light-to-dark contrast ratio of 10:1 compared to a 100:1 contrast for print (Bunnelle, 2000). Finally, a series of proofreading experiments demonstrated that reading on a CRT is inherently 10% to 30% slower and 10% to 20% less accurate than reading print on paper (Ziefle, 1998; Wright & Lickorish, 1983).

On balance, it is not clear that most consumers are likely to find that current e-book technologies offer significant relative advantage over print. Although control of font and character size is an advantage for the visually impaired, the increased expense and lower quality image are likely to be perceived as significant negative incentives to adoption.

Producers of e-book readers have gone to considerable trouble to make the e-book experience as much like "reading" as possible. Most e-books permit underlining, highlighting, and annotating text in ways similar to what readers are accustomed to doing with printed books. Readers have rocker switches that permit users to "flip" pages, and some readers even offer sound effects as pages change (Bunnelle, 2000)

Despite these "homey" touches, most people are still more comfortable with printed volumes. A recent University of Virginia study of contemporary reading habits found that paper was preferred "for actual consumption (reading) of information" whereas electronic media were most accepted for searching and retrieval of information (Bunnelle, 2000). Other studies have shown that people tend to print out computer content that exceeds 500 words (Crawford, 1998). Clearly, for most readers, experiencing John Grisham through a book is a different experience from experiencing his work through a flat-panel display, providing another barrier to adoption.

On balance, it is clear that the primary barrier to consumption of e-publishing is the adverse impact of existing technology. In both the analysis of relative advantage and compatibility, there appear to be more negative than positive values. There appear to be few barriers for authors and at least as many potential advantages as disadvantages for publishers. Existing distributors are essentially irrelevant to the process because they can either participate or be ignored. Consumers, for whom the expense and disadvantages of technology and the discomfort of adjusting to a new style of "reading" represent comparative disadvantage, appear to be the key roadblock to developing an e-publishing critical mass audience.

ELECTRONIC PAPER

Two U.S. firms are rapidly developing commercial-quality, reusable electronic paper. Both firms are spin-offs from prestigious research institutions. Gyricon Media

Inc. was founded in 2000 by former Xerox Corp. researchers who had been involved in researching SmartPaper at the company's PARC Laboratories in Palo Alto, California. E Ink was founded by former researchers from the MIT Media Laboratory and has been working on development issues in partnership with Lucent and other technology firms (Duran, 2002).

Although using somewhat technically different approaches, both firms are seeking to perfect a reusable, electronically programmable paper suitable for a number of applications. Both expect their products to be commercially viable within five years. Both products are capable of taking an image and holding it until another electrical stimulus is applied. Current resolutions are about 100 dpi but are expected to go to 300 dpi in the near future (Duran, 2002). Although both firms are presently focusing on commercial applications such as promotional and pricing signage for stores, Joseph Jacobson, a cofounder of E Ink, said his ultimate goal is to create a book of several hundred pages with enough memory chips in the spine to hold the entire Library of Congress (Ditlea, 2001).

E-paper boasts several advantages over current display technology. It is five times brighter than LCD displays, uses 99% less power, and is as thin and flexible as a sheet of regular paper (Battey, 2001). Given the availability of a display that feels very much like paper, looks very much like paper, and provides an image that is significantly superior to existing e-publishing readers, what is the likely impact on consumer adoption?

Such a product would, it seems likely, remove much of the resistance identified in the earlier analysis. Although it is not yet possible to predict costs for an e-book based on this technology, it seems reasonable to assume that if E Ink plans to manufacture the product cheaply enough for use in retail promotional and pricing signage, manufacturing costs cannot be exorbitant. A battery life measured in months instead of hours and an improved display that addresses physical stress issues resolve two other impediments to adoption. Finally, while retaining desirable characteristics such as the ability to control font and size displays, e-paper mimics the function of real paper in a way that should address both the issues of differential rates of reading and retention and the psycho/social issues identified in the University of Virginia study. In short, it appears likely to significantly enhance the adoption rate for e-publishing products and facilitate the development of a critical mass of users.

IMPLICATIONS FOR INDUSTRIAL STRUCTURE

With the establishment of a critical mass audience for e-publishing products, the current highly structured and concentrated book publishing industry will face significant challenges from previously nonexistent competitors and from the need to modify the industry business model to exploit new revenue streams. New competi-

tion will spring from outside firms, self-publishing new authors, and established writers who may decide to bypass the publishing process.

Already firms such as fatbrain.com and Ebookstand.com operate on a business model based on the resale of work produced by those who are either unwilling to deal with major publishers or whose work has been rejected by those publishers (Bunnelle, 2000). Even more frightening to publishers is the possibility that established writers currently in their stables might decide to self-publish their work. Such a move could increase the author's royalties from 10% to 15% to nearly 100%, the only expenses being the maintenance of the web site. Nor are these models far fetched; the Stephen King story mentioned earlier illustrates the drawing power of authors with established reputations. Two anecdotal stories illustrate the reality of other alternatives. In 2000, Maxine Thompson, founder and president of Maxine Thompson's Literary Services, decided to self-publish three books and a short story collection that had been rejected by a number of traditional publishers. Her first-year sales were more than $40,000 and were expected to double in the second year (Palmer, 2001). When Frank Weyer's mystery, *MIT Can Be Murder,* was rejected by 10 literary agents who refused to even forward it to publishers, he forwarded by e-mail the first chapter of his 210-page work to 18,000 alumni of MIT and other universities. Some 1,400 recipients subscribed to the novel, which was released in 12 monthly installments (Ditlea, 2000). These kinds of competitive issues will differ in quantity, though not particularly in kind, from existing competitive factors. The major challenge facing traditional publishers will be how to enter the field fully and retain the control over content needed to generate appropriate revenue streams.

A NEW MODEL

Publishers' efforts to maintain content control over digital products similar to the degree of control they presently hold over printed products are doomed to failure. As the music industry has demonstrated, encryption schemes are invented to be broken. The other major strategy publishers are using—creating files that are designed for use only on a specialized reader—runs directly counter to the open standards needed to grow the market. To survive and prosper, publishers will need to "let go" of content issues and pursue a series of strategies designed to minimize costs and leverage new revenue streams. Figures 1 and 2 illustrate the differences between the traditional and e-publishing industry structures.

The proposed model differs from the existing model in several respects. First, publishers will rationalize their e-publishing distribution stream to minimize costs. According to Sottong (2001), Kurzweil estimated that when a new technology supplants a mature technology, the older technology continues to coexist for 5% to 10% of the older technology's lifespan (Sottong, 2001). This means that both print and

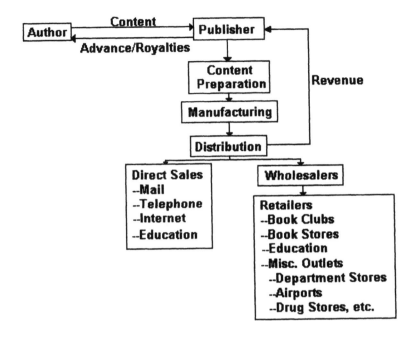

FIGURE 1 Existing industry model.

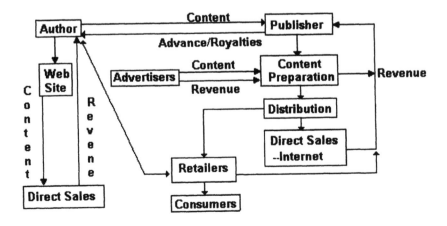

FIGURE 2 E-publishing industry model.

electronic publishing streams will likely coexist for some lengthy period of time. Publishers will need to centralize their electronic distribution functions in a central location under their control. With the Internet as a distribution channel, geographic proximity has no particular value. Publishers may have to continue to provide discounts to distributors of paper books; they may not need to share profits from e-publishing with third parties. More likely, publishers and retailers may cooperatively develop retail print-on-demand capabilities to achieve additional cost advantages for both partners and eliminate the need for existing wholesale distribution channels entirely.

Second, the new model multiplies the number of potential revenue streams. For publishers, the traditional revenue streams from direct sales are increased and potential revenues from advertisers and consumers are strengthened. New revenue streams from direct sales are created for authors, and retailers develop the capacity to assume the publisher function by developing direct relationships with authors.

Historically, book publishers have placed little or no reliance on advertising revenues. In fact, U.S. Postal regulations barred publications containing advertising from taking advantage of low book rates. Additionally, few advertisers were particularly interested in books as an advertising medium. With digital delivery, that picture could easily change. Postal regulations no longer apply. Advertisers are hungry to exploit new opportunities to reach target audiences and are willing to pay large amounts to do so as the growth in product placement advertising in film and on television demonstrates.

E-books provide an ideal vehicle for target marketing. Obvious cases involve advertisers such as hardware stores seeking placement in home repair books, or diaper services and baby food companies in baby care books. Less obviously, the collection of demographic or psychographic data from purchasers could be coordinated with already available Internet software to place the most appropriate set of ads into individual e-books. Advertisers would then pay either a flat rate for ads placed over a specific number of times or downloads, or a per-placement rate. To encourage downloads, publishers would minimize or eliminate download fees. This would have the effect of increasing downloads and reducing the incentive to pirate content. Since U.S. audiences have demonstrated considerable tolerance for advertising when it reduces or eliminates content costs, there is little reason to anticipate audience resistance to such an approach. Nor is the idea entirely new. In 1998, Glen Hauman abandoned a five-year attempt to sell downloadable books on the Internet. He placed all his titles online for free with banner ads and renegotiated his contract with his authors to provide for a percentage of ad revenue instead of royalties on sales. The result? Site traffic increased by a factor of 10 and revenues by a factor of 60. "We made more money in three months giving the books away than we made in five years trying to sell them," Hauman said (Milliot, 2000b).

EveryBook, one of the most expensive of the e-book readers, is also exploiting advertising. Using a proprietary download line, EveryBook downloads subscribed publications including advertising and boasts to prospective advertisers that it can

match consumer demographics with information about which ads they observed and how long they watched them (Schuyler, 1998).

Publishers will also have to adopt appropriate alternative pricing strategies for their digital products. As noted earlier, most publishers have been pricing e-book titles at or near the level of their print equivalents. Given the significant potential savings from digital production and distribution, such pricing can provide a healthy boost to margins, but it also depresses sales and encourages efforts to break encryption codes and copy content. The dichotomy was illustrated at an e-book conference in New York in 2000 when Henry Yuen, chief executive officer of Gemstar-TV Guide, suggested that issuing a new novel in a proprietary format could justify a $20 price and Steve Brill of Contentville proposed a $1.99 charge to encourage the development of the market.

One potential approach to revenue development, which offers the benefit of easing issues related to copyright protection, lies in the development of publisher subscription networks. Subscribers might pay a flat monthly fee of perhaps $10 to $20 and an additional fee of perhaps $1 per download for access to a publisher's entire catalog (Rawlings, 1991). Such an arrangement would secure publishers an on-going revenue stream, would represent a reduction in costs to the consumer who purchases several books a month, and would provide distribution at a cost low enough to discourage copyright violations.

Given a substantial period of overlap between paper and electronic publishing technologies, publishers will have to explore and exploit the ways in which their electronic publishing efforts can be used to promote their print products. One thing some musicians quickly discovered about Internet music banks was that they presented a great opportunity for exposure to new audiences. The same seems to be true of publishing. Science fiction publisher Jim Baen (eWebScriptions) experimented by offering readers $10-a-month subscriptions that entitled them to download each month one-quarter sized segments of four new titles he was about to publish. Baen noted that the move actually improved sales because "more of our subscribers buy the finished book than don't buy it" (Ditlea, 2000).

Adoption of the new model is unlikely to occur at an even rate across book publishing segments. Textbooks, which represented almost 15% of all books sold in the mid-1990s (Gomery, 2000), appear to be the top candidates for electronic publishing. E-books are lighter than traditional texts, the demographics of students are consistent with those of early adopters, and electronic texts offer features such as searchability and lower costs that make them attractive to their market (O'Leary, 2001). Some public school systems are already experimenting with electronic texts as a way of reducing costs and eliminating storage and delivery costs (Minkel, 2000).

The second most likely candidates for e-publishing are technical manuals, professional books, and reference books. These books typically are bulky in nature, often have short useful lives, and seldom elicit significant emotional involvement

from their owners (O'Leary, 2001). Indeed, a 2000 survey by Seabold Research found that 64% of respondents were interested in using e-books for accessing reference materials, maps, and travel guides (Larkin, 2000).

Adoption by consumers of fiction and nonfiction trade books is likely to be slower. Travelers, for example, are likely to be wooed by the advantages of weight and bulk when traveling but may be more reluctant to adopt electronic formats for entertainment reading. Other categories of books, particularly "coffee table" products and those aimed at the young children's market, are likely to remain in paper format the longest.

CONCLUSION

An analysis of the development of the e-publishing industry through the lens of adoption theory indicates that consumer acceptance of currently available technology is the largest barrier to attaining a critical consumer mass. New technologies centering on electronic paper will be available within five years. By providing a consumer alternative that is both superior in display and more natural in method, these technologies could very quickly yield a critical market mass. Among the major players in the publishing chain, authors are likely to respond positively to this development because it expands audience potential and even offers an opportunity to increase their revenues by going directly to their readers without the intervening publisher and distribution stages currently required. Publishers are likely to have mixed reactions. The opportunities are great, but nagging issues related to new competition, content control, and protection of revenue streams are likely to be seen as difficulties. Adoption of the new technology will also increase competition in the industry, opening the way to new publication channels and diversifying product content. By adopting strategies that stress rationalization of the distribution system to minimize costs, cross-promotion of print products through digital products, strategic pricing, and leveraging of new revenue sources—particularly advertising—publishers can turn these trends to their advantage. Those that fail to show the flexibility and adaptability required to meet changing technologies and circumstances will lose market share as the printed-on-paper market share of publishing declines.

Additional research on consumer adoptive behavior is needed as publishing applications based on electronic paper become practical. Determining the accuracy of predictions regarding the economic implications of a new technology based on adoption/innovation theory is important in assessing the potential for applying the methodology to other evolving communications sectors.

REFERENCES

Baker, J. (2000, July 10). UPs ponder publishing culture, E-book future. *Publishers Weekly, 247*, 9, 16.

Battey, J. (2001, April 16). Electronic paper gets its bearing. *Infoworld*. Retrieved June 28, 2002, from http://staging.infoworld.com/articles/hn/ml/0104/6/01016hnetrend.xml?Template=/storypages/printfriendly.html.

Bunnelle, J. (2000). The E-book: Future or fad? *Mississippi Libraries, 64*, 3–6.

Castelluccio, M. (2000, May). Books on glass and live numbers in print. *Strategic Finance Magazine, 81*(11), 85–86.

Crawford, W. (1998, January/February). Paper persists. *Online, 22*(1), p. 42.

Ditlea, S. (2000, July/August). The real e-books. *Technology Review, 103*(4), 70–78.

Ditlea, S. (2001, November). The electronic paper chase. *Scientific American*. Retrieved June 28, 2002, from http://216.239.35.100/search?q=cache:pkX4EMhpz HUC:www.sciam.com/2001/1101issue/1101ditlea.html+elecronic+paper&hl=en&start=1&ie=UTF-8&e=1416.

Duran, M. (2002, February). E Ink, Gyricon on pace to make reusable paper household name. *Newspapers & Technology*. Retrieved June 28, 2002 from http://www.newsandtech.com/issues/2002/02-02/ot/02-02_eink.htm.

Eberhard, M. (1999, March 8) E-book economics. *Publishing Weekly*, pp. 22–23.

Gomery, G. (2000). The book publishing industry. In B. M. Compaine & D. Gomery (Eds.), *Who owns the media* (pp. 61–146). Mahwah, N.J.: Lawrence Erlbaum Associates, Inc.

Greco, A. (1997). *The book publishing industry*. Boston: Allyn & Bacon.

Guthrie, R. (2002). The e-book: Ahead of its time or a burst bubble? *Logos, 13*(1), 9–17.

Isenberg, D. (2000, November 1). Not a bestseller, yet. *Internet World, 6*(21), p. 46.

Jantz, R. (2001). E-books and new library service models: An analysis of the impact of E-book technology on academic libraries. *Information and Technology Libraries, 20*(2), 104–113.

Kinsella, B. (2001, October 8). Seybold focuses on practical E-book issues. *Publishers Weekly, 248*, 12.

Lardner, J. (1999, September 6). A high-tech page turner. *U.S. News & World Report, 127*, 48–49.

Larkin, M. (2000, December 23). An e-book under the tree? *The Lancet, 356*, 2,205.

LaRose, R., & Atkin, D. (1992). Audiotext and the reinvention of the telephone as a mass medium. *Journalism Quarterly, 69*, 413–421.

Lichtenberg, J. (2001, November 19). Stalwarts keep the faith at E-book show. *Publishers Weekly, 248*, 17.

Maxwell, J. (2000, March 14). A new chapter for E-books. *Inc., 22*, 43–44.

Minkel, W. (2000). The e-textbooks are coming. *School Library Journal, 46*(9), 18–19.

Milliot, J. (2000a, April 3). AAP names task force to create E-book standards. *Publishers Weekly, 247*, 11–12.

Milliot, J. (2000b, March 6) Tomorrow's publishers today. *Publishers Weekly, 247*, 42, 44.

O'Leary, M. (2000, October). Bartleby.com reworks free E-book model. *Information Today, 17*(9), 20–22.

O'Leary, M. (2001, January) Ebook scenarios. *Online, 25*(1), 62–64.

Palmer, P. (2001, April). The e-book revolution: Self-publishing goes high tech. *Black Enterprise, 31*(9), 49–50.

Parker, E. (1996, August). *Early adoption of DBS*. Paper presented at the meeting of the Association for Education in Journalism and Mass Communication, Anaheim, CA.

Press, L. (2000). From p-books to e-books. *Communications of the AMC, 43*(5), 17–21.

Rawlings, G. (1991). *The new publishing: Technology's impact on the publishing industry over the next decade*. Retrieved on October 25, 2002 from http://www.roxie.org/papers/publishing/.

Reid, C. (2001a, December 17). Adobe not giving up on E-book market. *Publishers Weekly, 248*, 15.

Reid, C. (2001b, May 7). Princeton University Press offers 'E-book plus.' *Publishers Weekly, 248*, 22.

Rogers, E. (1962). *Diffusion of Innovations*. New York: Free Press.

Rogers, M., & Roncevic, M. (2002). E-book aftermath: Three more publishers fold electronic imprints. *Library Journal Net Connect* (Winter), 4, 8.

Schuyler, M. (1998). Will the paper trail lead to the E-book? *Computers in Libraries, 18*(8), 40–43.

Sottong, S. (2001). E-book technology: Waiting for the "false pretender." *Information Technology and Libraries, 20*(2), 72–80.

Von Stroh, R. (1993). Computer vision syndrome. *Occupational Health & Safety, 62*(10), 62.

Wright, P., & Likorish, A. (1983). Proof-reading texts on screen and paper. *Behaviour and Information Technology, 2*(3), 227.

Ziefle, M. (1998). Effects of display resolution on visual performance. *Human Factors, 40*(4), 554.

JOURNAL OF MEDIA ECONOMICS, *16*(2), 87–95

The Effects of Differential Textbook Pricing: Online Versus In Store

Sarah Maxwell

Department of Marketing
Fordham University

The pricing of textbooks has been complicated by the Internet. Should the price be the same both online and in store? Should the price be lower over the Internet? If so, how much lower? And if it is lower, will that affect the campus bookstore's reputation? The results of the present study suggest that lower prices online will have no negative effect on the bookstore's reputation, partly because students expect online prices to be lower and partly because the reputation of campus bookstores is already low. Although students are generally trusting, they trust neither the bookstore nor the publisher. Students do, however, recognize that the bookstore is fast and convenient, and nearly a third say they would purchase textbooks in store even if online prices were cheaper. In addition, there is evidence that in actual practice fewer students would take advantage of cheaper online sales than those who say they will. Furthermore, those who would purchase online are probably already doing so. Consequently, it appears that providing a discount online would capture the price-sensitive student segment without jeopardizing in-store sales or reputation.

The advent of e-tailing has created a new problem for sellers: how to price a product sold in both brick-and-mortar stores and over the Internet. Should the price be the same through both outlets? Should the price be lower over the Internet? If so, how much lower? And if it is lower, will that affect the campus bookstore's reputation?

A bookseller's reputation can be harmed if a lower price over the Web suggests that the seller has been getting excess profits in their brick-and-mortar stores. Buyers may ask themselves why these excess profits have not been shared. They may infer that the seller has been exploiting the customer, an inference that will damage the buyers' trust in the seller. Such a loss of consumer trust can have a long-term effect

Requests for reprints should be sent to Sarah Maxwell, Department of Marketing, Fordham University, New York, NY 10023. E-mail: smaxwell@fordham.edu

on the seller's reputation. The purpose of the present research is to explore the short- and long-term effects of differential pricing, specifically for textbooks purchased in a campus bookstore (in store) versus over the Internet (online).

BACKGROUND

Key to any pricing strategy is the consumers' reference price, the price the consumer expects to pay. Reference prices are important because they provide the baseline for consumer judgments of whether a price is cheap or expensive (Winer, 1986).

Previous research (Maxwell & Maxwell, 2001) has indicated that consumers, in general, have lower reference prices for the Internet. In particular, students expect textbook prices to be 16% lower online than the prices offered in store. As a result, students start with the belief that any purchase over the Internet *should* be cheaper than a purchase from a brick-and-mortar store.

Some retailers use consumers' lower Internet reference price as a means to segment price-sensitive customers. These retailers use their Web site to promote lower prices and sale items. An example is The Gap clothing chain: It features only sale items over the Internet, thus centralizing the disposal of slow-moving products. The prices are roughly 30% less than those in its retail stores.

Other retailers use the Internet as a means to encourage in-store sales. They use their Web site to provide information on product specifications and availability, but not price savings. An example is the giant toy store, Toys-R-Us. It prices items exactly the same over the Internet as in the store, charging Internet customers extra for shipping and handling. Instead of using the Web as a medium for targeting more price-sensitive consumers, Toys-R-Us uses it for encouraging retail-store traffic. To this end, it offers special coupons online that are good only in store.

Booksellers use a combination of both strategies. For nontextbook sales, major bookstore chains such as both Borders and Barnes and Noble provide hardbacks and older paperbacks at savings of 20% to as much as 80%. Their strategy for textbooks (as well as new paperbacks), however, is to charge the same online as in bookstores. With the added costs of shipping and handling, their textbooks are actually more expensive online than they are in campus bookstores.

The goal of Borders and Barnes and Noble may be not to cannibalize their on-campus bookstore sales, but their success is questionable. Price-sensitive students have been able to find cheaper textbook prices in other sites such as Varsitybooks.com or eCampus.com. Although those sites are now in bankruptcy or have been delisted, other low-price online booksellers like Walmart.com will continue to appear. However, by providing the lower price expected over the Web, a bookseller like Borders could counter competition and maximize its yield without cannibalizing in-store sales or harming its reputation. How a lower price online could damage students' trust in the campus bookstore is depicted by the price/trust model.

PRICE/TRUST MODEL

The proposed price/trust model for textbooks considers the effects of price differential and dispositional trust on choice of outlet and situational trust in the bookseller (see Figure 1).

Price Differential

Traditional economic theory suggests that when the price online is lower than that offered in store, more students will purchase books over the Internet. What is less obvious, however, is whether offering a lower price online will have a negative effect on consumer trust. If a lower online price raises buyers' doubts about the higher in-store price, and if the buyers then infer that the seller has been acting opportunistically, then it is expected that the lower online price will decrease trust in and increase perceived unfairness of the campus bookstore.

Dispositional Trust

Trust can be defined as a confident and positive expectation in respect to another's conduct (Lewicki, McAllister, & Bier, 1998). According to McKnight, Cummings, and Chervany (1998), trust can be either dispositional or situational. Situational trust is the specific trust engendered in the situational. Dispositional trust is the product of a person's personality and background.

Researchers such as Yamagishi and Yamagishi (1994) have shown that there is a direct relationship between dispositional and situational trust: A violation of

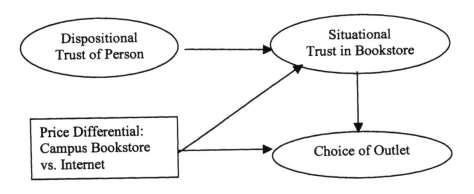

FIGURE 1 Price/trust model.

dispositional trust results in lower situational trust. There is inconclusive evidence, however, as to the strength of the effect. Bradach and Eccles (1989) argued that people with higher dispositional trust will start with lower expectations that others will act opportunistically. Those with higher dispositional trust will also be less affected by what appears to be opportunistic behavior because "trust gives rise to beliefs that are highly resistant to evidence" (Jones, 1996, p. 16). The implication is that students with more positive dispositional trust will maintain a higher level of trust in the campus bookstore even when their trust has been breached.

However, trust, like fairness, also has an emotional element. When consumers' sense of fairness is violated, they make negative attributions as to the seller's intentions and methods of pricing (Campbell, 1999; Maxwell 2002). The same can be applied to trust. When trust is breached, consumers feel personally violated and are more likely to be enraged. People high in dispositional trust can therefore be expected to react more strenuously to what they perceive to be violations of trust. For example, Yamagishi (2001) demonstrated that when negative information is provided, both high and low trusters lower their estimation of another's trustworthiness, but high trusters have a stronger response. The implication is that those buyers who have higher dispositional trust will believe that sellers are less likely to act opportunistically.

Situational Trust

Situational trust is the trust felt within a specific context. It can be further subdivided into benevolence trust and competence trust (Ganesan & Hess 1997; Selnes & Grønhaug, 2000; Singh & Sirdeshmukh, 2000). Benevolence trust is defined as the belief that another will act in your own best interest (Garbarino & Lee, 2001). Competence trust is defined as the belief that a firm has the necessary technical ability to fulfill its promised service in a reliable manner (Garbarino & Johnson, 1999; Singh & Sirdeshmukh). It is assumed here that students take the competence of the campus bookstore for granted. The concern is, consequently, the students' trust in the seller's benevolence, in the seller's genuine concern for the welfare of the students even at the expense of the seller's own profit.

Economic exchange has traditionally been considered a low-trust situation (Blau, 1964). It is therefore anticipated that students' trust of the bookstore will generally be low. All things being equal, however, the level of the students' trust in the bookstore's benevolence is expected to influence their choice of where to buy their textbooks. Those who have greater trust in the bookstore will tend to purchase their textbooks in store; those who have less trust in the bookstore will be more inclined to purchase online. Situational trust is therefore expected to have a direct and positive effect on choice of outlet. It is also expected to have a negative effect on estimates of profitability: Students who have lower situational trust are

expected to think that the publisher and the bookstore are exploiting them. They will consequently have higher estimates of the profitability of both the bookstore and the publisher.

STUDY

To test the proposed relationships, a 2 × 3 survey-based experimental study was conducted with two levels of price and three levels of dispositional trust. Scenarios were used to manipulate the price differential between the campus bookstore and the Internet. One group received a scenario in which the price over the Internet was the same as that in the bookstore; the other group received one in which the online price was lower than the in-store price. Dispositional trust was measured and divided into three levels. The respondents' choice of outlet was the dependent measure.

Participants

The participants were 72 undergraduate business students in the author's marketing classes. The participants completed the survey for extra credit. The students were either juniors or seniors; they therefore had had ample opportunity to gain experience with the bookstore. The survey was designed to ask two questions in which the only logical responses were diametrically opposed. Those respondents who gave the same answer to both, as well as those who skipped multiple questions, were removed, leaving 64 useable responses.

Pricing

The price of the textbook was set at $110, the bookstore price of the most widely used marketing textbook. The Internet price, when lowered, was $90, an 18% reduction, more than the 16% generally expected on the Internet but less than the 20% minimum discount typically given on books. The typical shipping and handling costs of $3.99 were not included.

Instrument

Dispositional trust was measured with the Generalized Trust scale developed by Couch, Adams, and Jones (1996). Situational trust was measured with the Benevolence Trust scale based on those used by Sirdeshmukh, Singh, and Sabol (2002);

Selnes and Grønhaug (2000); and Garbarino and Lee (2001). All items were measured on a 7-point, Likert-type scale ranging from 1 (*totally agree*) to 7 (*totally disagree*). Factor analysis was used to check on the unidimensionality of the dispositional- and benevolent-trust constructs. All items loaded on the expected two factors. The smallest loading was 0.7. To identify three levels of dispositional trust, the items were averaged and segmented into low (1 to 3.5), medium (3.6 to 4.5), and high (4.5 to 7).

After specifying which outlet they would use to purchase the textbook, students were asked to explain why they made that selection. The responses to this open-ended question provided an in-depth understanding of their choice processes.

RESULTS

As expected, when the price was lower over the Internet, students were more likely to say that they would purchase their textbooks there ($p < .00$). There is, however, no relationship between dispositional trust and situational trust, nor is there any relationship between a lower price online and a lower situational trust. What is significant is the relationship between dispositional trust and perceived fairness of the price: 55% of those high in dispositional trust rated the bookstore price fair, whereas 75% of those low in dispositional trust rated the bookstore price unfair ($p = .07$).

The effects of differential pricing are stronger on perceived fairness than they are on trust. Although 57% considered the bookstore price fair when it was the same as that offered online, only 27% considered it fair when the online price was cheaper ($p = .02$). The perceived fairness of the price has a significant influence on the students' choice of where to purchase their books: 56% of those who thought the bookstore price fair planned to buy the book in the bookstore; 79% of those who thought the price unfair planned to buy the book over the Web ($p = .01$). Not surprisingly, affluent students are more likely to think the bookstore price of $110 to be fair than are less-affluent students: 55% of those who are well off thought the price fair, whereas 90% of those less well off thought it unfair, ($p = .05$).

The expectation that a lower price on the Internet would raise the students' estimates of how much profit the bookstore or the publisher was making was unfounded. There was no significant difference between the estimates when online and in-store prices were the same compared to those for when the prices differed. Students, on average, estimated bookstore profits of 24%, which is very close to the 23% pretax profit on new course textbooks reported by the retailing industry.

Student estimates of publishers' profits, however, were much higher than their estimates of the bookstore's profits: On average, students predicted that publishers made a 64% profit on the textbooks they distributed through campus bookstores. Such an unreasonably high profit estimate might be attributed to the students' lack of "real world" knowledge if it were not for the relative accuracy of their estimates

of the bookstore's profit margins. It appears that students place the primary blame for the high price of textbooks on the publishers. They evidently feel that publishers are exploiting them more than the bookstore is.

To booksellers, the survey's most important result is that when the bookstore price was the same as that offered on the Internet, 93% of the students said they preferred to buy at the bookstore. Even when the textbook was cheaper online, 29% of the students still said they favored buying in the bookstore. The primary reason for preferring the bookstore, given in the open-ended questions, was "More convenient," or in other words, "Because it's easier; I'd pick it up after class." Other reasons students gave were speed of delivery and recognition of the Web's hidden costs of shipping and handling: "Because I can get the book faster"; "I wouldn't have to wait for it to be delivered"; "Because it will cost you more with shipping and handling and take more time to receive"; "I don't have to worry about shipping charges, giving my credit card out, or return policy."

A few students mentioned their lack of trust in the Internet: "I don't trust the Internet for making online purchases; in the event you want to return something it is a great hassle using the Internet source." Another small minority worried about giving out their credit card number to the Internet: "Too lazy to go on the computer and give them my credit card #, which I don't like to do"; "I wouldn't have to give my credit card # on line or worry about when and if it would come in the mail."

Only a very few students said they would purchase online regardless of whether the online price was cheaper than that at the bookstore. The reason they gave was their intense distrust of the campus bookstore. They made comments like "I hate the bookstore; the people are mean, ignorant, and stupid," and "I am used to the bookstore ripping me off already; I would rather give my money elsewhere." No one mentioned the avoidance of state sales tax, even though it added more than 7% to the purchase.

When the price was lower over the Web, most students cited savings as the reason for purchasing online: "It's cheaper. ... I'm a college student and don't have a lot of money to be spending on books"; "$ is the bottom line in that game." Their economic reasons were tempered, however, by their trust in the online e-tailer: "Because it is cheaper; Barnes & Noble is recognized as a trustworthy business; I would be comfortable purchasing the book from the Web from B&N."

DISCUSSION

The strong message of this study is that campus bookstores are perceived to provide a benefit of speed and convenience. The Web is valuable only as a cheaper but less convenient alternative for the price-sensitive consumer. It appears, however, that booksellers with outlets both online and in store could keep their more price-sensitive shoppers by offering a discount on their Web sites. How much that discount can be before it would cannibalize the current in-store sales is still in question. The

study results indicate that 71% of the students would switch to the Web if the online price were 18% lower than the in-store price. This result, however, is suspect.

A problem with any survey is that subjects tend to respond as they feel they *should* respond. Their answers are strongly influenced by the dictates of social norms. One of these norms is that of economic rationality: Consumers are expected to make decisions based on their own best self-interest. As expected, respondents to this survey reported that if the price on the Internet were $20 cheaper on a $110 purchase, they would buy it online. The result was magnified for less-affluent respondents. Actual experience, however, shows that students do not demonstrate such a rational response to lower prices online.

According to the National Association of College Stores, of the $6.6 billion spent on textbooks, less than 6% is actually spent online (Uhland, 2001). The small percentage spent on textbooks online is still greater than the 1.4% of entire discretionary income that students in general spend online (Tedeschi, 2002). Despite the press hype about e-tailing, the reality is that only a small percentage of students are actually making online purchases.

This study indicates that lower online prices will not negatively affect the bookstore's reputation. The impact of lower online prices on students' trust in the bookstore appears to be weak because students already have such low situational trust: 79% reported very low trust in the bookstore. This contrasts sharply with the students' very high dispositional trust: 55% rated themselves very trusting. This strong difference overshadows any additional effect caused by a price differential between the bookstore and the Web. It appears that students already feel that the bookstore is "ripping them off." Students simply accept the lower online prices as confirmation of an already strongly held belief.

CONCLUSION

Campus bookstores could compete with online sellers by simply lowering their prices by 15%. If they did this, however, they would need to more than double their sales volume just to maintain the same profits. This is not going to happen. Campus bookstores need alternative ways to compete. One possibility is to provide price concessions that demonstrate their concern for the customer without cutting prices across the board. Examples are a discount on sales above a certain amount, a donation of 1% to the college football team, or a "scholarship" book fund for needy students.

Bookstores can also compete on nonprice attributes. They can, for example, assure the immediate availability of required texts. They can stress customer service by facilitating returns or filling special orders quickly. They can explore the possibility of extra services such as sponsoring a book club or automatically prepackaging all the books students need for their particular course loads.

Whereas online booksellers can compete primarily on price, in-store booksellers can compete primarily on service. They can demonstrate a real concern for the students' welfare. By doing so, they will build benevolent trust. With greater trust, students will likely consider bookstore prices to be fairer, even if the in-store prices are higher than those offered online.

REFERENCES

Blau, P. (1964). *Exchange and power in social life.* New York: Wiley.

Bradach, J. L., & Eccles, R. G. (1989). Price, authority, and trust: From ideal types to plural forms. *Annual Review of Sociology, 15,* 97–118.

Campbell, M. (1999). Perceptions of price fairness: Antecedents and consequences. *Journal of Marketing Research, 36,* 187–199.

Couch, L. L., Adams, J. M., & Jones, W. H. (1996). The assessment of trust orientation. *Journal of Personality Assessment, 67,* 305–323.

Ganesan, S., & Hess, R. (1997). Dimensions and levels of trust: Implications for commitment to a relationship. *Marketing Letters, 63,* 70–87.

Garbarino, E., & Johnson, M. S. (1999). The different roles of satisfaction, trust, and commitment in customer relationships. *Journal of Marketing, 63,* 70–87.

Garbarino, E. & Lee, O. (2001, October). Dynamic pricing in Internet retail: Effects on consumer trust. *Paper presented at the Fordham University Pricing Conference,* New York.

Jones, K. (1996). Trust as an affective attitude. *Ethics, 107*(1), 4–25.

Lewicki, R. J., McAllister, D. J., & Bier, R. J. (1998). Trust and distrust: New relationships and realities. *Academy of Management Review, 23*(3), 438–458.

Maxwell, S. (2002). Rule-based price fairness and its effect on willingness to purchase. *Journal of Economic Psychology, 24*(2), 191–212.

Maxwell, S., & Maxwell, N. (2001, October). Channel reference prices: The potentially damaging effects of Napster. *Paper presented at the Fordham University Pricing Conference,* New York.

McKnight, D. H., Cummings, L., & Chervany, N. L. (1998). Initial trust formation in new organizational relationships. *Academy of Management Review, 23,* 473–490.

Selnes, R., & Grønhaug, K. (2000). Effects of supplier's reliability and benevolence in business marketing. *Journal of Business Research, 49*(3), 259–271.

Singh, J., & Sirdeshmukh, D. (2000). Agency and trust mechanisms in consumer satisfaction and loyalty judgments. *Journal of the Academy of Marketing Science, 28*(1), 150–167.

Sirdeshmukh, D., Singh, J. & Sabol, B. (2002). Consumer trust, value and loyalty in relational exchanges. *Journal of Marketing, 66*(1) 15–37.

Tedeschi, B. (2002, March 11). E-commerce report. *The New York Times,* C8.

Uhland, V. (2001, August 27). Colleges bailing out of book biz. *Rocky Mountain News,* 1B.

Winer, R. (1986). A reference price model of brand choice for frequently purchased products. *Journal of Consumer Research, 13,* 250–256.

Yamagishi, T., & Yamagishi, M. (1994). Trust and commitment in the United States and Japan. *Motivation and Emotion, 18*(2), 129–166.

Yamagishi, T. (2001). Trust as a form of social intelligence. In K. Cook (Ed.), *Trust and society* (pp. 121–147). New York: Russell Sage Foundation.

JOURNAL OF MEDIA ECONOMICS, *16*(2), 97–120

The Rise and Not-Quite Fall of the American Book Wholesaler

Laura J. Miller

Department of Sociology
Brandeis University

This article uses historical and interview data to examine the transformation of the wholesale sector in the American book industry. In contrast to the dominant pattern in other consumer goods industries, book wholesalers went from being relatively marginal in much of the 19th and 20th centuries to being central to book distribution and marketing in the 1970s. The increased clout of the wholesale sector in those years paralleled the growth of small presses on the one hand, and giant bookstore chains on the other. Since the 1990s, there has been consolidation as a considerable number of distributors have gone out of business. This has implications for the diversity of books available in the retail book market. It has also encouraged wholesalers to take on more of the traditional functions of publishers and retailers.

Among the least glamorous segments of the book industry is that responsible for wholesaling and distribution. Wholesalers concern themselves with scheduling shipments in trucks rather than author appearances in the media, and with designing efficient warehouses rather than attractive bookstores. As such, they are mostly invisible to authors and the reading public. But wholesale distribution plays a far more important role in the book industry than most outsiders assume. This was recently made evident with the financial troubles of Canadian distributor General Distribution Services (GDS). When parent General Publishing Co. was forced to declare bankruptcy in April 2002, dozens of the small presses GDS carried, including some of Canada's most respected publishers, were themselves put in danger of going under. Similar fates have befallen American presses when their distributors collapsed, though no distributor failure to date has had the same impact on the national book scene as the General disaster has had in Canada.

Requests for reprints should be sent to Laura J. Miller, Department of Sociology, Brandeis University, Waltham, MA 02454–9110. E-mail: lamiller@brandeis.edu

At first glance, the book business looks like other consumer good industries where a major concern is the smooth and speedy movement of product from multiple producers (in this case, publishers) to the thousands of retail outlets that sell the items.[1] And similar to many industries, the system of book distribution has been altered in important ways by the entry of mass retailers. Yet, as the GDS incident suggests, book distribution does not neatly fit the typical pattern exhibited in other industries, in which wholesalers have become increasingly irrelevant over the last century. Instead, book wholesalers were infrequently used by retailers during the first part of the 20th century and then grew in importance during the 1970s. The increased centrality and clout of the wholesale sector in those years paralleled the growth of small presses on the one hand, and giant bookstore chains on the other. During the last decade, the fortunes of many distributors have turned, and a sizeable number have gone out of business. Nevertheless, publishers and retailers continue to remain dependent on the largest ones.

In this article, I discuss the significance and some unique aspects of the changes that occurred during the 20th century within the wholesaling and distribution of trade books, those aimed at the general public. After reviewing the history of this sector, I describe how the wholesaler became a key player in the industry during the 1970s and 1980s. This happened as wholesalers helped independent booksellers diversify their selections in the face of increased competition from chain bookstores and mass merchandisers, as wholesalers became an important source of marketing and merchandising information, and as a new category of distributor emerged to support the multitude of small publishers that formed at this time. At least until the mid-1990s, it appeared that a strong system of national, regional, and specialized distributors was finally institutionalized in the book industry.

The era that spawned so many new and innovative distributors may have been short-lived, however, as numerous wholesalers have gone out of business since the 1990s. In part, this phenomenon mimicked a process that occurred much earlier in other industries, with massive publishers and chain bookstores controlling an increasing share of the market and a greater part of the machinery of distribution. Still, this is not a simple story of wholesale decline. In contrast to other fields, the difficulties of predicting and regulating demand in the book business makes it unlikely that mass retailers and the large publishers can squeeze out wholesalers altogether. Furthermore, while many distributors have fallen by the wayside, a few companies, most notably Ingram, Baker & Taylor, and Advanced Marketing Services, have gained considerable power within the book industry. As I will argue, the consolidation that has taken place within wholesaling is potentially threatening

[1]Publishers, of course, are not the actual manufacturers of books. There are separate companies that specialize in the printing and binding of books. However, publishers are the ones who coordinate and assume the financial risks in the production of books. Therefore, they play a similar role to manufacturers of other consumer goods.

to the diversity of books to which Americans have access; in some ways, this threat is greater than that posed by developments in retail bookselling, which have received so much more attention. For the choices that readers have in retail outlets depend on which titles booksellers can easily obtain. As no wholesaler can carry every book in print, booksellers require an assortment of suppliers to be able to offer the widest selection of books. Consequently, the public has a real stake in the future of the wholesale sector.

THE CHANGING STATUS OF THE WHOLESALER

According to business historians Alfred D. Chandler (1977) and Susan Strasser (1989), the heyday of the wholesaler in the American consumer economy was the mid-19th century. At this time, jobbers (wholesalers who resold to retailers after buying goods outright from manufacturers instead of selling on commission) were the primary link between manufacturer and retailer, most of whom were relatively small and spread out over the enormous expanse of the continent. Jobbers played an important financial role as they provided cash to manufacturers before the retail sale was made, and as they often provided credit to their retail customers. The wholesaler was also the most important sales tool the manufacturer had before the development of national brands and mass marketing. Through personal calls on retailers, the wholesaler was able to drum up business for a product, hence earning the term "drummer."

The centrality of the wholesaler began to wane in the late 19th century with the development of mass production and mass retailing. Expanding consumer goods manufacturers nurtured the capability of distributing products directly to retailers and took advantage of mass communication media to create demand among consumers for specific brands. These producers who took control of distribution, sales, and marketing could then eliminate the services of the wholesaler. On the other end, new mass merchants—department stores, mail-order houses, and chain retailers—increasingly bypassed wholesalers by contracting directly with manufacturers and by developing their own warehouses and distribution systems. Consequently, wholesaling experienced a steady decline in the 20th century, a phenomenon accelerated in the last few decades with the gains made by huge chain retailers.[2]

However, the history of wholesaling in the book industry looks rather different. In the years preceding the Civil War, book wholesaling on anything other than an ad hoc basis appears to have been practically nonexistent. Rather than relying on established organizations to gather the output of dispersed publishers and then resell it to

[2]On the advantages for firms of cutting out intermediaries such as the wholesaler to achieve vertical integration, see Williamson (1971, 1985). For sociological critiques of this perspective, see Fligstein and Dauber (1989) and Perrow (1990).

interested booksellers, the book trade made use of auctions and trade sales, which brought dispersed booksellers to a central site to peruse and acquire their goods. The book auction, primarily a phenomenon of the colonial period, was a practical means for recycling books in a society where such items were still relatively scarce. Auction houses sold off collections from personal libraries and sometimes the stock of booksellers; they were thus mainly engaged in selling used books. Trade sales, which developed in the early 19th century, were a method for publishers to dispose of large lots of books. In some cases these can be considered the first sales of what are now called "remainders"—publishers' overstock to be sold very cheaply. Both booksellers and the general public traveled to trade sales, hoping to find items at reasonable prices (Sheehan, 1952; Tebbel, 1972; Zboray, 1993).

The trade sale declined in the years following the Civil War, and in its place came travellers—commissioned salespeople hired by publishers to visit booksellers around the country—and true wholesalers who carried the products of a mix of publishers. Nevertheless, wholesalers were few in number and unevenly distributed through the country. Their perceived effectiveness was quite limited due to their inability to provide significantly and consistently faster service than publishers gave. Processing orders and shipping books any further than a few hours' drive from the wholesaler's warehouse could take a considerable amount of time, and booksellers complained that they could not count on their nearest wholesaler to have in stock the books that they needed. Wholesalers were not much better positioned than publishers to cope with the vast geography of the United States; as late as 1949, only one wholesaler had regional warehouses (Miller, 1949).

The jobbers' position was made even more precarious by the tendency of publishers to compete with them for the retailer's business, and by retailers' erratic utilization of their services. From the late 19th century until the 1950s, the country's dominant book jobbers were the American News Company, Baker & Taylor, and A. C. McClurg. One 1933 study estimated that 90% of books distributed through jobbers were handled by these three firms (Wheeler, 1933). Yet, this same study claimed that only 25% of books sold went through any jobber; the rest were bought by retailers directly from publishers (p. 240). An important exception to this pattern was the way in which softcover book distribution was organized. From the dime novels so popular in the 19th century to the paperbacks that took off in the 1940s, softcovers were distributed in the same way as were periodicals. Primarily sold out of newsstands, softcovers were serviced by magazine distributors who would periodically come by to remove old periodicals and books and drop off new ones. For the better part of a century, the American News Company controlled the newsstand distribution of most national magazines as well as softcover books.

As this suggests, jobbers before the 1960s were less likely to be used by so-called regular booksellers, those retail stores devoted exclusively to books. Instead, wholesalers were used primarily by nonbook retailers—drugstores, stationers, newsstands, and small department stores—as well as by public and rental

libraries and the smallest of bookstores (Wheeler, 1933). All these outlets carried a highly limited selection of titles, though they actually reached a wider audience of readers than bookstores did. The result for wholesalers was both economic and status-related: They were deprived of the business of the largest book outlets, and they also appeared less legitimate in the eyes of book professionals who had contempt for the nonbook retailers.

The lack of a healthy wholesaling sector was a frequent topic of discussion and cause of frustration among book industry leaders. Reformers argued that the resulting efficiencies of using jobbers would more than offset the wholesaler's cut of profits because publisher and retailer would have to deal with only one account instead of the many. Both the landmark 1931 Cheney Report on the state of the book industry (Cheney, 1931) and a 1951 report commissioned by the American Book Publishers Council (1951) asserted that a strong system of wholesalers that warehoused essentially all in-print books was important to improving distribution, and thus the economic well-being of the industry as a whole. The two reports condemned a situation in which wholesalers were utilized only by the most marginal of retailers or only for rush orders, which were the most expensive to fill and brought in the least amount of profit to the jobber—"nuisance service" as Cheney put it (p. 230). Proponents of an enlarged role for wholesaling agreed that jobbers needed to be able to handle large orders as well as small (see, e.g., A. C. Vroman, Inc., 1955). Nevertheless, through the 1950s, the wholesale sector remained on the margins of the industry.

THE MAINSTREAMING OF THE MARGINAL

This situation finally started to change in the 1960s, and by the following decade, the use of wholesalers had increased significantly. This happened for a number of reasons. In the first place, several types of nonbook retailers formed or expanded existing book departments at this time, including supermarkets and discount variety stores such as K-mart (Miller, in press). Such retailers had little interest in hiring a staff of trained booksellers who could navigate the constantly changing universe of books in print; they were quite happy to arrange instead for wholesalers to make stocking decisions. Department stores, which formerly had been among the most important sources of books for Americans, were now another promising client for wholesalers. As department stores scaled back their large book selections in urban stores and established small book departments in suburban branches, they too were more likely to utilize the one-stop-shopping services of wholesalers than to invest in staff who knew how to deal with multiple publishers.

Regular bookstores were also beginning to find wholesalers more valuable, especially when it came to certain types of nontraditional books and publishers. This included the paperback, a format that was traditionally of lower status than

hardcovers and that had largely been the province of drugstores and newsstands. But booksellers found it increasingly difficult to ignore the popularity of the paperbacks. No longer just associated with a working-class readership, paperbacks were being used in college classrooms, and the ever-growing numbers of college-educated readers felt little hesitation in continuing to purchase the economical paperbacks once they left campus. Readers were also coming to expect softcovers in the bookstore; in the 1950s and 1960s, all-paperback shops sprung up, which greatly supplemented the offerings of nonbook outlets.

For those regular booksellers who were willing to carry paperbacks, one impediment was the sources of supply. Because of the way in which paperback distribution had evolved, most booksellers could not buy softcovers directly from publishers. Instead, they had to deal with the ID (independent distributor) wholesalers that had replaced American News Company as the distributors of periodicals and mass market (rack-sized) paperbacks. Booksellers resented this arrangement, in part because they preferred the cost savings of purchasing direct from publishers, but also because of the IDs' habit of "force-feeding." Such force-feeding methods started with the paperback publishers, who generated a "suggested" allotment of books for their national distributors. After accepting this invariably inflated allotment, the national distributors then pressured the local IDs to take far more books than could reasonably be expected to sell, and these, in turn, were dumped on the retailer, who had to accept everything the ID gave in order to obtain the titles that would actually move off the racks (Klein, 1953; Smith, 1975, 1978).

As booksellers grew more vocal about the problem, a new kind of wholesaler appeared during the 1960s, one who specialized in providing bookstores with paperbacks. These wholesalers were not part of the ID system, did not service newsstands, and did not carry magazines or other nonbook materials. Although they initially concentrated on stocking "quality" (trade) paperbacks, these jobbers later supplied their customers with mass market books as well. Together with some regular hardcover wholesalers who also began to carry paperbacks, the bookstore-oriented jobbers presented booksellers with alternatives to the IDs.

An even greater contribution to the bookseller's new-found need for wholesalers was the profusion of small presses that were established beginning in the 1960s.[3] The small press had long been a component of the American book world, but in the 1960s, it went, in the words of Henderson (1984), from a tradition to a movement (see also Henderson, 1975). Many new publishing efforts grew out of

[3]What constitutes a small press is, of course, a matter of debate. Henderson (1984) defined a small press as one that is run by few people, publishes few titles, and specializes in works that larger publishers would reject for commercial or editorial reasons. While others would dispute any content-based definition, most would agree that size of operation does matter. As one gauge of how to assess size, in 1992, only 500 publishing establishments in the United States had 20 or more employees (U.S. Bureau of the Census, 1995).

the social movements of the era; in the 1970s, numerous presses were also formed as offshoots of the interest in self-help and spirituality. Would-be publishers were additionally aided by developments in printing and other means of duplication, which lowered the financial resources and expertise needed to make a book. Then, with advances in desktop publishing programs, by the 1980s, anyone with a home computer and some spare time could become a publisher. As a result, the number of individuals and organizations publishing books increased dramatically. The total number of publishers went from 2,350 in 1958 to 10,803 in 1978 (Robinson & Olszewski, 1980). As of 2001, there were 69,210 publishers in the United States, most of them small (*Books in Print 2001–2002*, 2001). One estimate is that a million books a year are now published by 50,000 small presses (Schwartz, 2000).[4]

From the bookseller's perspective, the explosion of small presses was a mixed blessing. Booksellers often appreciated the diverse offerings of these publishers, particularly as independents were trying to differentiate themselves from mall-based chain booksellers, which carried a small and predictable selection of titles. But the difficulties of dealing with so many different suppliers were considerable, especially when many of these presses were inexperienced in the ways of the industry. It was therefore beneficial for the retailer to use wholesalers; time and paperwork were greatly reduced when ordering from, and paying bills and shipping returns to, a single wholesaler instead of multiple publishers.

To serve the complex publishing scene that developed, wholesalers who specialized in particular categories, such as religious books or poetry and literary books or small presses, were founded. For instance, Berkeley-based Bookpeople went from being a paperback wholesaler to one known for its "alternative" titles when it began distributing the *Whole Earth Catalog* and John Muir's *How to Keep Your Volkswagen Alive* in the early 1970s. ("They Bought the Company," 1991; Trueheart, 1983; Weise, 1993). In addition to such wholesalers, a new kind of distributor emerged to provide specialized services to a limited number of client presses. More than just a wholesaler, this distributor (sometimes called a master or exclusive distributor) generally acts as a press' exclusive representative, handling sales and marketing for it as well as fulfillment. The exclusive distributor sells the publisher's books both directly to retailers and to other wholesalers. Thus, the distributor takes on some functions of the publisher.

[4]Getting an accurate count of the number of publishers in the United States is very difficult. The U.S. Census Bureau uses a highly narrow definition of what qualifies as a publisher and so excludes an enormous number of small presses, university presses, and the presses of other nonprofit organizations. More comprehensive figures come from the R.R. Bowker Company, which publishes the standard bookselling reference, *Books in Print*. Although most publishers report to Bowker in order to get their books listed in *Books in Print*, not all do so, and not all listed publishers have ongoing publishing concerns. Still, the Bowker figures, on which the mentioned estimates are based, are probably the best for getting a sense of how many publishers are actually out there.

Perhaps the first venture of this kind was seen in 1958 when the Taplinger Publishing Co. started to distribute and promote small publishers (Taplinger, 1962). But this sort of organization was a rarity until the 1970s. As the number of small publishers increased in these years, competition for the bookseller's attention and shelf space grew accordingly. And as the number of retail outlets for books grew, dealing with the universe of bookstores became much more complicated for all publishers. With the formation of Independent Publishers Group in 1971 ("Book Sense Welcomes," 2002), Publishers Group West in 1976 (See, 1989), and others that followed them, master distributors achieved significant success in getting the books of their clients into independent and chain bookstores, as well as into the warehouses of major wholesalers. Indeed, without representation by an exclusive distributor, or at least by a wholesaler such as Bookpeople that specializes in small publishers, most small presses face a tremendous struggle to get retailers to even consider carrying their books. As one bookseller told me in an interview,

> Whenever I talk to people trying to sell me a book from a small publisher, especially if it's something that I want, I really try and encourage them to get it to a distributor. Because if they get it to a distributor, I can get it right away because I have an account with the distributor. But I don't want to open an account with a small publisher because I'm taking a chance. I mean if these books don't sell, I have this credit from this publisher that I probably don't want anything else from. And also a lot of them starting out, frankly, don't even know about distributors. They have no idea how things work; they just think to call up every bookstore and try and get them to open an account with you. ... In fact, a lot of this whole big stupid phone system we have is to protect me from these people. [laughs] Because all day, I get calls from authors and from publishers, you know, all the time. And it's not that I don't want to sell books. I mean it's just that I simply cannot buy books one at a time.

For the novice publisher, distributors may be the only ones to take the time to offer guidance on book design, obtaining an ISBN (International Standard Book Number), and other elements that mark a publisher's books as worth taking seriously. And for just about any small press, wholesalers and exclusive distributors may represent the only real chance of getting its books into outlets. These middlepeople have truly become key to many a small publisher's survival.

MODERNIZING THE WHOLESALE SECTOR

The growth of alternative formats and organizations spurred the increased use of specialized distributors. But other developments encouraged retailers, especially independent booksellers, to utilize traditional wholesalers for obtaining books

from publishers both large and small. Those wholesalers were aided by the adoption of new technologies that enabled them to achieve the efficiencies that had eluded them for so long. Booksellers now found that most books could be obtained much faster from a wholesaler than when ordering direct from the publisher. Wholesalers also used technology to provide booksellers with a centralized source of information about title availability and marketing plans. The ways in which technology contributed to the growth of the wholesaler can be seen in the histories of the country's two largest distributors, Ingram and Baker & Taylor.

When asked about changes that have occurred in distribution over the last few decades, many industry personnel point to the growth of these two companies. Of course, the concept of a national wholesaler is not a new one. Throughout the 20th century there did exist wholesalers who served a national market, the American News Company being the dominant one. But until the 1960s, American News was the only jobber with regional warehouses, which in effect meant that other wholesalers were limited in how wide-ranging a presence they could establish. This finally started to change in 1962 when Baker & Taylor, then the country's second largest wholesaler, opened two new warehouses in Chicago and Dallas to complement its existing New Jersey facility ("$100,000 Settlement Ends," 1962; "McClurg Merger Hearing," 1962). By the end of that decade, American News was leaving book jobbing, and A. C. McClurg, the other prominent wholesaler of the mid-century, had been swallowed up by another company.[5] But Baker & Taylor was among those that managed to successfully negotiate the transition into a modern, technologically sophisticated organization. Indeed, in several ways, the company's evolution mirrored the transformation of many of the old family-owned publishing houses into rationalized, corporate enterprises.

Baker & Taylor had its beginnings as D.F. Robinson & Co., a Hartford, Connecticut, bindery founded in 1828. As was the case with many book industry enterprises in these years, the firm soon engaged in multiple aspects of book production and distribution, first establishing a publishing component, and then in 1830, opening a bookstore as well. A few years later, it moved to New York to carry on its activities, which by this time also included some wholesaling. Over the years, as different combinations of partners took control of the firm, the company went through nine name changes but finally settled on Baker & Taylor in 1885. By then, the firm division of labor that developed in the book industry following the Civil War also characterized Baker & Taylor as the company had increasingly concen-

[5]In 1969, the American News Company changed its name to Ancorp National Services. It appears that shortly thereafter, it phased out its book wholesaling business and concentrated more on its food-service and newsstand operations. The company had several years of financial and legal difficulties (including an investigation into organized crime activities), and then in 1979, Ancorp merged with a unit of Sodexho, a French food-service company. See "American News Co." (1969); "American News to Seek" (1969); "Ancorp National Services Inc." (1979); "Ancorp to File" (1973); Kessler (1969a); Kessler (1969b).

trated on jobbing after 1864. In 1912, it sold its remaining publishing operations and from then on was known exclusively as a wholesaler.

The company enjoyed a fair degree of stability for the next several decades, maintaining its status as the country's second largest book wholesaler. But in the late 1950s, at the time that mergers and acquisitions were starting to engulf publishing houses, Baker & Taylor began to experience a series of changes in ownership. First, in 1958, it was sold to Parents' Institute, Inc., the publisher of *Parents Magazine*. Then in 1969, it was acquired by W.R. Grace, a corporation best known for its shipping activities, but by then, diversified into chemicals, real estate, and retailing. Finally, in 1992, Grace sold Baker & Taylor to a private group consisting of The Carlyle Group, a merchant bank, and some top Baker & Taylor managers (Freilicher, 1973; Mills & Dematteis, 1986); "Private Group Agrees," 1991; Tebbel, 1972, 1975; The Reference Press & Warner Books, 1995).

One reason for Baker & Taylor's longevity and key position in the industry is its history of providing extra services to libraries and retailers in addition to simple fulfillment. For instance, in the 1920s, it was offering to provide department stores with prepackaged book departments (Advertisement, 1920). Twenty years later, it had similar programs for rental libraries and offered a book selection service to bookstores through which Baker & Taylor could provide a new shop with its initial stock and even continue to select and ship new books to it. For those stores that desired to do their own selection, Baker & Taylor produced a number of catalogs that provided guidance on new and backlist books. Since 1898, its *Book Buyer's Guide* had been considered an essential reference tool for any American bookseller.[6] Along with these selection aids, Baker & Taylor made available many other services to libraries, including the cataloging of books, and the preparation of plastic book jackets, spine labels, cards, and book pockets (Baker & Taylor Co., 1940; Freilicher, 1973). These services still continue to be central to Baker & Taylor's appeal to its customers.

Although Baker & Taylor remained an important jobber for both booksellers and rental libraries, from the years following World War II until 1973, the company focused its business on serving public, school, and academic libraries (Dessauer, 1974). In the mid-1970s, Baker & Taylor once again embarked on a program to gain a greater presence in the retail market ("Baker & Taylor Touts," 1976; Compaine, 1978; Freilicher, 1973). By 1996, retail sales accounted for approximately 30% of Baker & Taylor's business (Mutter & Milliot, 1996).

Because of its emphasis on institutional customers, Baker & Taylor remained secondary to Ingram Book Co., the country's other major national wholesaler, in terms of trade book sales. Within a relatively short time, Ingram became an extremely important force in American bookselling; one 2000 estimate is that it

[6]Baker & Taylor's guide was still cited as a must-have resource for booksellers in 1969. See, for example, Houlihan (1969).

controls 55% of the American book wholesale market (Arthur Donner Consultants Inc., & Lazar and Associates, 2000). Ingram's roots are in the Tennessee Book Co. (founded in 1935), a small textbook distributor that was partially acquired in 1964 by the Ingram family. The Ingrams, descendants of a founder of the Weyerhauser Corp., had amassed enormous wealth through timber, barge transportation, and oil businesses.[7] In 1969, they hired Harry Hoffman (later the president of Waldenbooks) to head their Ingram Book division. Under Hoffman, the company was reoriented away from institutional accounts toward serving the retail market, and within a few years, it became the major trade book distributor in the South (Magruder, 1973; Milliot, 1995; Summer, 1995; The Reference Press & Warner Books, 1995).

Over the next few years, Ingram expanded its reach into the Northeast and Midwest. But it finally achieved a national presence in 1976 when it acquired a California book wholesaler, the Raymar Book Corp. Raymar, at the time the largest trade book wholesaler on the West Coast, owned warehouses in southern California and Washington, and regional warehouses were essential if a wholesaler hoped to provide stores in a given territory with quick service. Through acquisitions and construction, Ingram added additional warehouses to its stock, and by 1994, it owned seven of them around the country, though this number was subsequently reduced to four ("Ingram to Acquire," 1976; Mutter, 1994; "Ingram Cuts 54," 2002).

Like Baker & Taylor, Ingram began to offer stock-selection programs and book catalogs to its customers. But what really helped Ingram to grow so quickly in the 1970s was its innovative use of technology. When Harry Hoffman arrived to head Ingram Book Co. in 1969, he brought with him a background in information access technology, having formerly worked at Bell & Howell, best known for its microfilm systems. In 1972, Ingram became the first wholesaler to provide booksellers with information on available stock via microfiche. Today, it is hard to imagine any industry's wholesale sector trying to get by without sophisticated information and communication systems. Yet, Ingram's introduction of microfiche was considered a marvelous innovation at the time. For the first time, booksellers could receive on a weekly basis an up-to-date listing of all books available from their wholesaler, as well as information on when new and out-of-stock books would come in. This data allowed booksellers to accurately predict when they would be able to get needed titles from Ingram and, therefore, to engage in more rational planning. Booksellers were also now able to supply customers with honest assessments about the timing of book orders, thus increasing the store's credibility (Compaine, 1978; Magruder, 1973; Symons, 1986).

[7]In 1978, the two Ingram brothers went their separate ways with one brother taking the family's oil interests, and the other, E. Bronson Ingram, taking the rest, including Ingram Book Co., which remained a subsidiary of Bronson's Ingram Industries.

Furthermore, Ingram made available a separate fiche of marketing information. Once again impressing booksellers with the opportunity to stay up-to-date, this fiche included dates of when book reviews and author appearances on television would occur, current best seller lists, and Ingram's recommendations for future hot titles. Ingram's marketing information helped booksellers not only to order those books that were currently selling well, but also to order in advance books that were probably going to sell well because of special promotion. In other words, booksellers were now better able to ride the popular book wave—and as a consequence, helped to make popular books even better sellers.

Other technological breakthroughs were also forthcoming, most of which added to wholesalers' abilities to get books to the retailer faster and more accurately. Seemingly simple developments gave wholesalers an edge they had never had before. For instance, another Ingram innovation in the mid-1970s was the installation of a toll-free phone number for bookseller customers to use when ordering. For the "backward" book industry, this was a new idea and was among those factors that helped drive Ingram's success. A further example was the introduction of United Parcel Service (UPS), which wholesalers began to use extensively in the late 1970s. As one wholesaler told me, UPS made a great difference in effectiveness:

> Customers' demands have increased, and they want books yesterday. And many years ago, we used to use the mails to get the books delivered, and it took four or five weeks. And we used to use those little private trucking services, and it was cumbersome and inefficient. Now that we have UPS it's very, very efficient to get books around the country.

After decades of being castigated for inefficiency, the wholesaler could finally promise speed and convenience in getting the books to the retailer. But as important as these various innovations were, they were soon superseded by the impact of computerization on distribution.

The offices of most wholesalers are relatively modest looking—nothing plush, not especially roomy, often just a handful of rooms for buying, sales, orders, and accounts payable and receivable. In contrast, the warehouses of these wholesalers tend to be imposing places —vast spaces with towering racks of books arranged in a seemingly haphazard fashion, forklifts rising up and down the stacks, boxes going down conveyer belts, and a few humans walking around with computer printouts in their hands. The activities that take place in these warehouses depend almost entirely on computer systems that determine the most efficient ways of directing the work, from how books are arranged on the racks to when orders will be shipped to customers. For instance, in most warehouses today, the computer decides where books are placed, often putting the most frequently ordered titles in one area, and the less popular titles in another. But book placement tends to be much more complicated than this suggests. In order to make the best use of space,

the stock of a single title may be scattered about in different "cells," that is, the shelf location. When a retailer's order comes in, it is the computer that guides "pickers" as they gather the requested books. The efficiency all this produces is no small matter; one wholesaler told me that automation had cut down the time taken to fill a large order from nearly a full day to less than one hour.

The warehouse is not the only area that has seen efficiency improved due to computerization. In the late 1980s, electronic ordering by retailers began to be institutionalized. During the prior decade, Ingram had again led the way when it used its computers to verify customers' orders as they came in—order takers could immediately inform customers over the phone whether and how many of a book was on hand (Youngstrom, 1981). But it was not until later that booksellers installed systems that made possible computer-to-computer communication for ordering purposes. Booksellers could use these systems to place orders electronically, instantly finding out what would be shipped to them, price changes, and other pertinent information.

The effect of all this technology was to drastically reduce the amount of time it took retailers to place orders and wholesalers to fill orders, and to greatly improve the retailers' ability to get all the books they needed without going to the more inefficient publisher. Consequently, this enabled booksellers to implement "just-in-time" ordering, whereby smaller quantities of books are ordered more frequently, and only as they are needed. Instead of using valuable space to store large numbers of a single title, the bookseller then has the room to keep a broader range of titles on hand, knowing that a title can be replenished quickly when all copies have been sold. This was especially important as the growth of chain superstores made a diverse selection of books essential to staying competitive.

Thus, wholesalers went from being relatively peripheral to being integral to the work of book retailers. Quantifying the extent of this change is not simple because estimates of wholesaler usage by bookstores vary considerably. In the mid-1990s, such estimates ranged from 20% to 40% of book orders (see, e.g., Mutter & Milliot, 1996; "NAIPR Meets with Ingram," 1996; Scott, 1994, 1996). On the face of it, this does not seem like such a big increase over previous decades. But what probably occurred, and what the gross numbers hide, is that independent booksellers greatly increased their use of wholesalers since the 1970s, whereas use by chain bookstores was more uneven. During the 1970s and 1980s, when the typical chain outlet was a small store with a limited selection of quick-turnover titles, most of its stock came from the major publishers. Thus, the chains bought primarily direct from publishers and thus did not substantially contribute to wholesaler growth. But in 1990, the chain superstore appeared, and for the next several years, the chains made greater use of wholesalers to fill up all those shelves in their giant stores. By the late 1990s though, the chains had invested in building distribution facilities that allowed them to lessen their use of wholesalers. This does not mean that the chains abandoned wholesalers altogether. For instance, in 2001, Borders

arranged for Ingram to provide fulfillment services for the retailer's special orders (Borders Group, Inc., 2002). The chains also continue to use distributors for their dealings with the smaller presses.

Similarly, the growth of the online retailer Amazon.com has had mixed results for wholesalers. Initially, Amazon relied on wholesalers, especially Ingram, to fulfill orders placed on its Web site. But then Amazon spent huge sums of money (contributing to its chronic inability to show a profit) on building its own network of warehouses, which diminished its need for wholesalers. But like other retailers, Amazon found the headaches of dealing with small presses quite costly and determined that it made financial sense to contract with wholesalers to supply some books (Hansell, 2001). In other cases, the growth of e-commerce has benefited wholesalers in a more straightforward manner. With the exception of Barnesandnoble.com, most Internet retailers selling new books utilize wholesalers to drop ship to customers' residences. That is, when a customer orders from an online retailer, the order is transferred to a wholesaler from whose warehouse the book is shipped. This allows online retailers to offer a far larger selection of books than what they have room for in their own physical storage facilities.

Altogether, by the end of the 1970s, it was clear that the wholesaler had become central to the distribution process. What was perhaps less clear was what that meant for the balance of power in the book industry. The new prominence of the wholesale sector raises various questions that go well beyond matters of efficiency and technological innovation.

WHOLESALE INFLUENCE

The role of the wholesaler has generally been perceived as an almost mechanical one of funneling books from publisher to outlet, devoid of the judgments and evaluations made by both publishers and booksellers. However, this view is not an entirely accurate one, for the wholesalers' activities and decisions most certainly affect the fate of various books as well as the fortunes of various organizations.

In the first place, wholesalers, especially the major ones, have become one of the primary sources of information on books for many retailers. The information provided by wholesalers is used not only for back-room functions, but is also consulted when responding to customer inquiries. Because many store inventory control systems are connected to Ingram's database, the clerk who looks up a book's availability may be consulting Ingram, not *Books in Print*. Publishers and other wholesalers often complain that clerks do not bother to check the other sources that their stores are authorized to use. In such cases, if a book is not contained in Ingram's database, it may erroneously appear to be completely unavailable to the customer requesting it. Because of the importance of being listed with Ingram, small publishers have sometimes even paid to be affiliated with entities that are

large enough to be carried by Ingram (*Sell More Books at Bookstores Through Distributors*, 1997).

Furthermore, wholesalers are not simply passive carriers of books; they actively shape booksellers' choices through marketing and recommendation programs. Wholesalers have been paying more attention to marketing during the last couple of decades; indeed, their growing marketing expertise is one of the things that has given wholesalers a more prominent role in the distribution process. Said one in an interview,

> Wholesalers have become more active in aggressively promoting sales rather than in just sending out a catalog and making the books available. For us, that means visiting stores, calling stores, sending faxes to stores letting them know. Attending a lot more trade events, you know, just encouraging publishers to do advertising and promotions. And I think that the wholesaler may have previously been somebody that was not operating in the same way that a publisher traditionally was, through doing marketing techniques and so on. The wholesalers are doing that a lot more. They're [now] operating like giant publishers.

Like publishers, wholesalers focus much of their marketing efforts on promoting books to their retail customers. But wholesalers have also taken on an advisory or educational role, prodding and teaching their publishers how to engage in more effective promotion. Some wholesalers now sell their marketing expertise to booksellers as well. Ingram, for instance, offered a service that provided stores with newsletters and catalogs, and advice on reaching the media, using consumer mailing lists, and doing in-store promotions ("Ingram's White Bridge," 1995).

Wholesalers' influence is additionally extended through stock selection programs. Many, if not most, wholesalers have services for recommending stock to booksellers. This may take the form of a recommended inventory list for new booksellers. Wholesalers also commonly issue catalogs with recommended "best picks" in different subject areas. Additionally, a bookseller seeking to revamp or expand specific categories or appeal to a new demographic group can request a list of recommendations from the wholesaler. These programs are nothing new; Baker & Taylor has been offering variations on them since early in the century. But computerization allows wholesalers to offer more sophisticated and timely selection services than ever before. In the 1990s, Ingram developed programs whereby booksellers in effect turned over their buying functions to the wholesaler. With one, after filling out a grid specifying the characteristics of the books a bookseller stocked, Ingram determined, on an ongoing basis, what titles to send to the store and in what quantities (Scott, 1996). With another, retailers could automatically receive books in selected categories based on Ingram's evaluation of how well a title was expected to sell (Perlah, 1997). As distributors take a more active role in

both selection and marketing, their activities help to determine which books will be successful in reaching various audiences.

Perhaps the most significant dimension of wholesaling's influence is that a press' titles must be carried by a wholesaler or distributor in order to have any prospect of retail sales. This is especially true of small presses; it is absolutely essential to get picked up by one or more wholesalers, and preferably by a master distributor who will assist with sales and marketing. This presents a number of problems for the small publisher. To begin with, those publishers who do find a distributor are not always entirely satisfied with the arrangement. The most frequent complaints stem from the difference in discount (that is, the discount off the list, or retail, price) a publisher must offer a distributor compared to selling direct to a retailer. The major wholesalers will also often demand a higher discount from small presses than from the big publishers. And while many small presses appreciate the sales efforts distributors make for them, they may resent the agreement of exclusivity whereby all bookstore sales are required to go through the distributor (see, e.g., Kremer, 1991).

Furthermore, there are not enough distributors or wholesalers to handle all the presses that seek their services. And wholesalers themselves are limited in the number of titles they can carry and the number of publishers they can represent. Inevitably, many, if not most, presses get shut out of the pipeline. The wholesale sector thus operates as a filter that, in effect, screens a substantial number of books out of the retail book trade.

Adding to the squeeze, after two decades that saw the birth of so many new and novel distributors, the forces of consolidation moved in upon this sector. Even as more presses clamor to gain the assistance of wholesalers, several prominent distributors have encountered financial difficulties since the early 1990s. One harbinger of things to come occurred in 1991 when Ingram acquired Gordon's Books, an important regional wholesaler based in Denver. Gordon's had been attempting to gain more of a national clientele; as part of that process, it had constructed a new warehouse in Cleveland the year before. The wholesaler found itself overextended, however, and coupled with increased competition from a nearby Ingram facility, the move contributed to Gordon's demise ("Ingram to Acquire Gordon's Books," 1991; Reuter, 1991; Szabla, 1990). Gordon's fall demonstrated the difficulties involved in challenging the established national wholesalers.

Other significant distributor failures followed. In 1993, Bookslinger, a wholesaler of small press books, went out of business. Among the reasons for its financial woes, a Bookslinger owner claimed, was the tendency for successful small presses to leave wholesalers like his for larger distributors ("Bookslinger to Close," 1993). Then in 1995, two more prominent wholesalers ran into trouble. Golden-Lee, a wholesaler specializing in health, computer, and promotional books, declared bankruptcy. And Inland, a widely used wholesaler of leftist, multicultural, and gay and lesbian titles, did the same. Inland was subsequently

purchased by New Jersey wholesaler Koen Book Distributors, which announced that it would try to continue business with somewhat less than half of Inland's 1,000 publishers, while Inland's exclusive distributor arm, called InBook, was separately acquired by Login (later renamed the LPC Group), a Chicago distributor. The shakeout continued over the next several years with the failures of Pacific Pipeline, the main wholesaler for the Northwest; small press distributors Atrium, Fine Print Distributors, Access Publishers Network, and Subterranean Company; New Age distributors Moving Books and Blessingway Books; and regional wholesaler L-S Distributors. The most recent distributors to close down were the LPC Group and Seven Hills Book Distributors in 2002 ("Bankruptcy Court Approves," 1995; "Doors Close," 1997; Farmanfarmaian, 1997; "Fine Print Reportedly in Liquidation," 1997;"Golden-Lee Distributors," 1995; High, 1999; "Inland's Wilk to Manage," 1996; Kinsella, 1995, 1997; Kinsella & Farmanfarmaian, 1996; "Koen Agrees to Buy Inland," 1995; "Login Makes Offer," 1995; Mutter & Milliot, 1995; O'Brien, 1995a, 1995b; Reid, 2002; Rosen, 2000a, 2000b, 2000c; "Seven Hills Shuts Down," 2002).

In each of these cases, those publishers who were not immediately picked up by other wholesalers faced an extremely problematic future. Moreover, when distributors go out of business, they usually owe money to their client publishers. Although the sums involved would not be fatal to a larger publisher, small presses with few cash reserves can suddenly face bankruptcy. This happened with previous failures (e.g., Farmanfarmaian, 1996a) and occurred with the recent collapse of GDS and the LPC Group. Compounding the problem of disappearing distributors is that with increased competition for space, the standards for gaining entry into a distributor's warehouse go up. For instance, when the distributor Publishers Distribution Service (PDS) was acquired by Access Publishers' Network, the new parent announced that PDS' list of 300 small publishers would "probably be reduced to include just the most profitable companies" (Farmanfarmaian, 1996b). (In the end, Access and its remaining client presses also went out of business.) Thus, the dependency of small presses on distributors creates a high level of vulnerability.

The demise of so many distributors certainly did not empty the field of wholesalers. There are still wholesalers and distributors scattered across the country that work, with varying degrees of success, to get a wide variety of books into bookstores. But the failure of such well-regarded wholesalers and the continued growth of the two giants of wholesaling have substantially altered the distribution scene. Currently, the stocking decisions of Ingram and Baker & Taylor determine the choices of books that many retailers make available to readers, while the wholesalers' accounting practices help determine the cash flow of publishers (depending on when the wholesalers pay what they owe to the publisher) and of booksellers (depending on how much credit the wholesalers grant to the retailer). With fewer wholesalers to take their business to, publishers and booksellers must accede to terms favorable to the major distributors.

In recent years, Ingram and Baker & Taylor have been joined by another major wholesaler, Advanced Marketing Services (AMS), which is the main supplier to warehouse clubs such as Price/Costco. AMS has been expanding both internationally and domestically. One of its latest acquisitions was the small press distributor Publishers Group West. It remains to be seen how a firm specializing in the distribution of best sellers to mass merchandisers will integrate a company best known for distributing diverse books with low sales.

PRODUCERS, WHOLESALERS, AND RETAILERS: COMPETITION OR CONVERGENCE

The publishers, wholesalers, and retailers of books have long competed with, as well as depended on, one another as they work to sell books to readers. As in the past, wholesalers complain that publishers undermine them by instituting terms that make the wholesaler a less attractive option to the retailer. Small presses object to the exclusive agreements they have to sign with distributors, or resent their inability to obtain any of the more profitable direct orders from retailers. For their part, retailers try to get better deals by ordering direct from publishers and, in the case of the chains, even sometimes obtain a discount equivalent to that which publishers give to wholesalers. This competition that wholesalers face is nothing new. What is significant though, is that wholesaling has not been cut out, despite the growth of very large publishers and retailers.

The persistence of the wholesale sector in the face of large publishers and booksellers is something of an anomaly when compared to other industries. While the book industry is not totally unique in this regard (see, e.g, Oswald & Boulton, 1995, on the pharmaceutical industry), it does go against the dominant pattern for wholesalers to be disintermediated by large manufacturers and retailers taking over the distribution process. Yet, while the current shakeout among book distributors may continue, and so reduce the number of existing wholesalers, this sector is likely to endure, even if it is made up of just a few companies.

The book industry differs from most consumer goods industries in that it deals in thousands of objects that are not interchangeable with another, and that are constantly being retired and replaced. Along with this, the peculiarity of a cultural industry such as the book business is that consumer taste cannot be predicted and shaped to the extent that it is for other consumer commodities. This creates a situation of great uncertainty, as the retailer cannot be sure of what is going to sell and may not have on hand the books that do end up selling. The bookseller responds to this uncertainty in a few ways, all of which may be facilitated by using wholesalers.

In the first place, the retailer does try to shape demand to some degree through marketing efforts. As retail competition has grown fiercer, booksellers have invested more staff time and resources into marketing specific books as well as the

bookstore itself (Miller, 1999). By utilizing wholesalers' services in this area, retailers can deploy their (often small) staff more effectively. Secondly, retailers must be able to quickly obtain those books that unexpectedly strike a chord among the public. This may be a title suddenly selected by a television book club, or one whose author makes an appearance on a broadcast talk show. With little advance warning, retailers do not have time to wait for direct shipments from publishers. Even the major publishers have been unable to create distribution arms that can quickly and reliably ship orders to thousands of outlets. For small and midsized presses, such a task is well beyond their capabilities. For instance, after September 11, 2001, there was massive demand for books on the Middle East, Islam, and organizations such as al Qaeda. These were books that were for the most part published not by the major houses but by scholarly presses; in at least a few cases, these were publishers that were small and unequipped to deal with fulfilling numerous large orders. In such cases, wholesalers were essential. Furthermore, the bookseller copes with demand uncertainty by stocking a wide selection of books. Large publishers do sell most of the books that are read in large numbers, as evidenced by the best seller lists. But especially with the construction of huge superstores with vast shelf space to fill, the products of the major publishers are not sufficient for retailers. If nothing more than as window dressing (or wallpaper, as it is known in the industry), retailers need the books of alternative publishers, and thus need the wholesaler.

But some wonder how diversity will be preserved if only a small number of wholesalers acts as gatekeepers to retail distribution. As this independent bookseller remarked, the big wholesalers are cause for both appreciation and alarm:

> They're [Ingram] really providing a whole lot of services for booksellers. And I think they've really done a commendable job. I mean they are a big corporation with all the problems therein. I mean, I think in a sense that the power, Ingram is probably too powerful. And ultimately, concentration at the wholesale level is probably as dangerous as concentration at the retail level. And Ingram is the big game in town. But they are, in terms of looking out for their customers' interests, they really are very good at that. And they are providing services that booksellers need.

Ingram currently carries 650,000 titles from about 13,000 publishers (Ingram Book Company, 2002). This is surely an impressive selection. Yet, it still excludes a considerable number of publishers and published titles.

Furthermore, Ingram and Baker & Taylor cannot market all of their titles equally. Some will invariably get more attention than others. Discontent has been voiced, for instance, because Ingram acquired the religious book wholesaler Spring Arbor. Many Christian booksellers claim that under Ingram, Spring Arbor has lost buyers who understood the fine distinctions within the Christian market

(Ford, 2002). Similarly, some question how local tastes will be satisfied if wholesalers are focused on a national market. As one wholesaler put it,

> Ingram's not necessarily going to serve a wide range of thought and interest if they're the only people out there doing it. You need your Pacific Pipeline. You need your Moving Books. You need your Inland, New Leaf, Bookpeople. I mean that's the fresh blood. That's what is in touch with its community.

Just as the community bookstore can spotlight titles that may fit with local interests, the regional wholesaler can draw retailers' attention to titles that are less likely to resonate with readers elsewhere.

As Hirsch (1992) pointed out, the demand uncertainty that characterizes cultural organizations means that a cultural producer gains competitive advantage to the extent that the organization is able to control distribution channels. Producers in industries such as film, broadcasting, and music have been far more successful than publishers at controlling distribution. And so book wholesalers, at least the large ones, are not in danger of being eliminated. But as a response to financial pressures, what appears to be happening is a blurring of the boundaries between publishing, wholesaling, and retailing. The most notable attempt at doing this was the 1998 bid by Barnes & Noble, the nation's largest bookstore chain, to buy Ingram, the nation's largest book wholesaler. Barnes & Noble was especially keen to obtain Ingram's distribution infrastructure and expertise to aid Barnes & Noble's Internet bookselling efforts. But after considerable protest by booksellers and others in the book world, the Federal Trade Commission indicated that it would block the merger, and the deal was called off.

Although the government did not allow the formation of a giant, integrated retailer-wholesaler, distributors have been able to gradually include functions traditionally the domain of publishers or retailers. These have included the small-scale operation of retail outlets, a greater role in the marketing of books, the acquisition of small and medium-sized presses, and experiments with on-demand publishing. Therefore, competition has produced some convergence between the activities of publishing, wholesaling, and bookselling. This suggests that antitrust considerations could surface again for regulators. And so wholesalers, far from being irrelevant, remain at the heart of continuing instability in the book industry.

REFERENCES

$100,000 settlement ends Baker & Taylor–McClurg suit. (1962, December 17). *Publishers Weekly*, *182*, 16.

A. C. Vroman, Inc. (1955, June 4). A pilot plant for distribution. *Publishers Weekly*, *167*, 2,524–2,525.

Advertisement (1920, July 31). *Dry Goods Economist* (No. 3960), 87.

American Book Publishers Council. (1951). *The situation and outlook for the book trade.* New York: Author.

American News Co. (1969, May 1). *Wall Street Journal,* p. 25.

American News to seek name change, increased common, new preferred. (1969, March 19). *Wall Street Journal,* p. 38.

Ancorp National Services Inc. (1979, February 22). *Wall Street Journal,* p. 34.

Ancorp to file Chapter 11 petition today; newsstand operator also to sell food unit. (1973, March 20). *Wall Street Journal,* p. 10.

Arthur Donner Consultants Inc., & Lazar and Associates. (2000). *The competitive challenges facing book publishers in Canada.* Ottawa, Canada: Minister of Public Works and Government Services.

Baker & Taylor Co. (1940). *The modern book shop and rental library.* New York: Author.

Baker & Taylor touts retail service; Ingram sales continue up. (1976, March 1). *BP Report on the Business of Book Publishing, 1,* 2.

Bankruptcy court approves InBook purchase. (1995, December 11). *Bookselling This Week, 2,* 1, 3.

Book Sense welcomes two new publisher partners. (2002, April 4). *Bookselling This Week.*

Books in print 2001–2002 (54th ed., Vol. 1). (2001). New Providence, NJ: Bowker.

Bookslinger to close this week. (1993, April 26). *Publishers Weekly, 240,* 18.

Borders Group, Inc. (2002). *Form 10-K for the fiscal year ended January 27, 2002.* (Available from the U.S. Securities and Exchange Commission.)

Chandler, A. D., Jr. (1977). *The visible hand: The managerial revolution in American business.* Cambridge, MA: Belknap Press.

Cheney, O. H. (1931). *Economic survey of the book industry 1930–1931* (1st ed.). New York: National Association of Book Publishers.

Compaine, B. M. (1978). *The book industry in transition: An economic study of book distribution and marketing.* White Plains, NY: Knowledge Industry Publications.

Dessauer, J. P. (1974). *Book publishing: What it is, what it does* (1st ed.). New York: Bowker.

Doors close on Seattle's Moving Books. (1997, October 27). *Bookselling This Week, 4,* 1.

Farmanfarmaian, R. (1996a, September 2). Atrium publishers group folds. *Publishers Weekly, 243,* 9, 12.

Farmanfarmaian, R. (1996b, September 16). New distributors hustle to fill Atrium gap. *Publishers Weekly, 243,* 12.

Farmanfarmaian, R. (1997, June 16). Atrium ordered into Chapter 7. *Publishers Weekly, 244,* 15.

Fine Print reportedly in liquidation. (1997, December 15). *Bookselling This Week, 4,* 3.

Fligstein, N., & Dauber, K. (1989). Structural change in corporate organization. *Annual Review of Sociology, 15,* 73–96.

Ford, M. (2002, August 5). Burns to replace Arthur at Spring Arbor. *Publishers Weekly, 249,* 18.

Freilicher, L. (1973, October 15). The new Baker & Taylor is 145 years old. *Publishers Weekly, 204,* 45–46.

Golden-Lee distributors files for Chapter 11. (1995, September 11). *Bookselling This Week, 2,* 3.

Hansell, S. (2001, May 20). Listen up! It's time for a profit. *New York Times,* pp. BU1.

Henderson, B. (1975). Independent Publishing: Today and yesterday. *Annals of the American Academy of Political and Social Science, 421,* 93–105.

Henderson, B. (1984). The small press book: A cultural essential. *Library Quarterly, 54*(1), 61–71.

High, J. (1999, February 22). L-S Distributors closing. *Publishers Weekly, 246,* 23.

Hirsch, P. M. (1992). Processing fads and fashions: An organization-set analysis of cultural industry systems. In M. Granovetter & R. Swedberg (Eds.), *The sociology of economic life* (pp. 363–383). Boulder, CO: Westview.

Houlihan, H. J. (1969). ABC's of stocking the bookstore. In C. B. Anderson, J. A. Duffy, & J. D. Kahn (Eds.), *A manual on bookselling* (1st ed., pp. 32–40). New York: American Booksellers Association.

Ingram Book Company. Frequently asked questions (FAQ). Retrieved October 27, 2002 from www.ingrambookgroup.com/Company_info/ibchtml/Resource_Center/ibc_faq.asj.

Ingram cuts 54; New DC opens. (2002, May 20). *Publishers Weekly, 249,* 17.

Ingram to acquire Gordon's Books. (1991, July 29). *BP Report on the Business of Book Publishing, 16,* 1; 5–6.

Ingram to acquire Raymar's wholesaling operations in nationwide expansion drive. (1976, August 16). *BP Report on the Business of Book Publishing, 1,* 1–2.

Ingram's White Bridge branching out. (1995, December 25). *Bookselling This Week, 2,* 1.

Inland's Wilk to manage LPC Group. (1996, March 25). *Bookselling This Week, 2,* 1.

Kessler, R. (1969a, July 3). Control of newsstands gives Henry Garfinkle power over publishers. *Wall Street Journal,* pp. 1, 17.

Kessler, R. (1969b, August 6). Crime strike force begins investigation into Garfinkle news-distributing firms. *Wall Street Journal,* pp. 30.

Kinsella, B. (1995, December 4). Login buy of InBook awaits court OK. *Publishers Weekly, 242,* 14.

Kinsella, B. (1997, February 10). Pacific Pipeline files for bankruptcy. *Publishers Weekly, 244,* 13.

Kinsella, B., & Farmanfarmaian, R. (1996, October 21). It's official: Atrium is now in Chapter Seven bankruptcy. *Publishers Weekly, 243,* 12.

Klein, R. (1953, December 19). The local wholesaler looks at small books. *Publishers Weekly, 164,* 2,386–2,392.

Koen agrees to buy Inland. (1995, September 25). *Bookselling This Week, 2,* 1.

Kremer, J. (1991, August). The unfair trade practices of book wholesalers. *Book Marketing Update,* 1.

Login makes offer for InBook. (1995, November 27). *Bookselling This Week, 2,* 1.

Magruder, M. (1973, April 30). The big new sound from Nashville: How the Ingram Book Company brought innovation to trade book wholesaling. *Publishers Weekly, 203,* 42–43.

McClurg merger hearing probes book wholesaling. (1962, September 3). *Publishers Weekly, 182,* 33–34.

Miller, L. J. (1999). Shopping for community: The transformation of the bookstore into a vital community institution. *Media, Culture & Society, 21,* 385–407.

Miller, L. J. (in press). Selling the product. In D. P. Nord, J. S. Rubin, & M. Schudson (Eds.), *A history of the book in America: Vol. 5. The enduring book: Print culture in postwar America.* New York: Cambridge University Press.

Miller, W. (1949). *The book industry.* New York: Columbia University Press.

Milliot, J. (1995, October 2). Ingram to form three separate companies; Pfeffer to retire. *Publishers Weekly, 242,* 10, 20.

Mills, T., & Dematteis, P. B. (1986). The Baker and Taylor Company. In P. Dzwonkoski (Ed.), *Dictionary of literary biography: Vol. 49, Part 1. American Literary Publishing Houses, 1638–1899* (pp. 34–35). Detroit: Gale Research Company.

Mutter, J. (1994, May 9). Ingram to open huge warehouse in Oregon this fall. *Publishers Weekly, 241,* 14.

Mutter, J., & Milliot, J. (1995, October 2). Koen to buy bankrupt Inland's warehouse operations. *Publishers Weekly, 242,* 11.

Mutter, J., & Milliot, J. (1996, January 1). Wholesale change. *Publishers Weekly, 243,* 44–46.

NAIPR meets with Ingram on VOR. (1996, December 9). *Bookselling This Week, 3,* 5.

O'Brien, M. (1995a, August 14). Golden-Lee down but not out. *Publishers Weekly, 242,* 11.

O'Brien, M. (1995b, September 4). It's official: Golden-Lee in bankruptcy. *Publishers Weekly, 242,* 11.

Oswald, S. L., & Boulton, W. R. (1995). Obtaining industry control: The case of the pharmaceutical distribution industry. *California Management Review, 38*(1), 138–162.

Perlah, J. L. (1997, May). Wholesalers: A service sector at a crossroads. *American Bookseller, 20,* 141–145.

Perrow, C. (1990). Economic theories of organization. In S. Zukin & P. DiMaggio (Eds.), *Structures of capital: The social organization of the economy* (pp. 121–152). Cambridge, England: Cambridge University Press.

Private group agrees to acquire Baker & Taylor. (1991, November 18). *BP Report on the Business of Book Publishing, 16,* 1, 4.

Reid, C. (2002, June 17). LPC liquidation likely. *Publishers Weekly, 249,* 10.

Reuter, M. (1991, August 2). Ingram plans to acquire Gordon's Books of Denver. *Publishers Weekly, 238,* 6–7.

Robinson, M. J., & Olszewski, R. (1980). Books in the marketplace of ideas. *Journal of Communication, 30*(2), 81–88.

Rosen, J. (2000a, December 11). Access Publishers Network to liquidate. *Publishers Weekly, 247,* 10.

Rosen, J. (2000b, September 4). Blessingway Books closes. *Publishers Weekly, 247,* 32.

Rosen, J. (2000c, July 3). Subterranean stops distribution. *Publishers Weekly, 247,* 19.

Schwartz, N. (2000, February 21). Think small press month. *Bookselling This Week, 6,* 1; 3.

Scott, R. T. (1994, September). The changing face of book wholesaling and distribution. *American Bookseller, 18,* VIII–X.

Scott, R. T. (1996, May). Taking new directions in the wholesaler market. *American Bookseller, 19,* 33–37.

See, L. (1989, May 26). Publishers Group West: Small press distributor hits the big time. *Publishers Weekly, 235,* 40–43.

Sell more books at bookstores through distributors. (1997). Traverse City, MI: Rhodes & Easton.

Seven Hills shuts down. (2002, July 29). *Publishers Weekly, 249,* 10.

Sheehan, D. (1952). *This was publishing: A chronicle of the book trade in the Gilded Age.* Bloomington: Indiana University Press.

Smith, R. H. (1975, March 31). Getting paperbacks to their readers. *Publishers Weekly, 207,* 24–29.

Smith, R. H. (1978, June 5). Paperback national distributors: Part I: The Big 11—Their origin and services. *Publishers Weekly, 213,* 75–78.

Strasser, S. (1989). *Satisfaction guaranteed: The making of the American mass market.* Washington, DC: Smithsonian Institution Press.

Summer, B. (1995, June 26). Obituaries. *Publishers Weekly, 242,* 25.

Symons, A. (1986, February 7). Ingram Book Company celebrates new facility. *Publishers Weekly, 229,* 43–44.

Szabla, E. (1990, October). Wholesaling in the '90s: Filling out to meet the market. *American Bookseller, 14,* 41–44.

Taplinger, R. (1962, December 24). Some ideas on book distribution. *Publishers Weekly, 182,* 16–18.

Tebbel, J. (1972). *A history of book publishing in the United States. Vol. I. The creation of an industry 1630–1865.* New York: Bowker.

Tebbel, J. (1975). *A History of book publishing in the United States. Vol. II: The expansion of an industry 1865–1919.* New York: Bowker.

The Reference Press, & Warner Books. (1995). *Hoover's guide to the book business* (2nd ed.). Austin, Texas: The Reference Press.

They Bought the Company. (1991, March). *American Bookseller, 14,* 103.

Trueheart, C. (1983, November/December). Bookpeople. *Small Press, 1,* 44–48.

U.S. Bureau of the Census. (1995). *1992 census of manufactures: Newspapers, periodicals, books, and miscellaneous publishing.* Washington, DC: U.S. Government Printing Office.

Weise, E. (1993, December 2). Book distributor to America's more esoteric readers. *Associated Press.*

Wheeler, C. T. (1933). The position of the wholesaler in the book trade. *Harvard Business Review, 11*(2), 237–243.

Williamson, O. E. (1971). The vertical integration of production: Market failure considerations. *American Economic Review, 61*(2), 112–123.

Williamson, O. E. (1985). *The economic institutions of capitalism: Firms, markets, relational contracting.* New York: Free Press.

Youngstrom, D. (1981, October). Caught in the middle: The predicament of the wholesaler today. *American Bookseller, 5,* 21–23.

Zboray, R. J. (1993). *A fictive people: Antebellum economic development and the American reading public.* New York: Oxford University Press.

JOURNAL OF MEDIA ECONOMICS, *16*(2), 121–138

Structure, Conduct, and Performance of the Agricultural Trade Journal Market in The Netherlands

Richard van der Wurff

The Amsterdam School of Communications Research ASCoR
University of Amsterdam

This article investigates how structure and conduct determine performance of the agricultural trade journal market in The Netherlands. It builds upon industrial organization theory and reviews relevant media market performance models. It shows how professional information prices and diversity follow from providers' strategic choices for lowest common denominator or product differentiation strategies. It attributes strategic choices to three underlying market structural characteristics, namely the balance between information and attention markets, concentration of information providers, and disintermediation. It concludes that prices and diversity, respectively, are determined by similar competitive relations but at different market levels.

Professional information is information that skilled workers need to know to accomplish their professional tasks. It is an important driver of competitive success, innovation, and sustainable development in a range of industries, including agriculture. This article discusses the conditions under which competing professional information providers reproduce and distribute this valuable resource as efficiently and effectively as possible.

Because relatively little is known about performance of professional information markets, this article builds upon general industrial organization and broadcasting market models. We define performance in terms of prices and diversity. We relate performance to strategic choices of information providers for lowest common denominator or to product differentiation strategies, and describe resulting market conduct in terms of market segmentation, competition within market

Requests for reprints should be sent to Richard van der Wurff, The Amsterdam School of Communications Research ASCoR, University of Amsterdam, Kloveniersburgwal 48, 1012 CX Amsterdam, The Netherlands. E-mail: vanderwurff@pscw.uva.nl

segments, and umbrella competition. We attribute strategic choices to three under-lying market structural characteristics, namely (a) the balance between informa-tion and attention markets, which is a typical characteristic of media markets (see Picard, 1989); (b) the concentration of information providers, which arguably is the most frequently studied determinant of market performance; and (c) disinter-mediation, which nowadays is extensively discussed in the e-commerce literature but which has existed much longer in publishing. We subsequently test the theoret-ical model with data on the Dutch agricultural trade journal market. Finally, we draw some conclusions and discuss implications for future research.

LITERATURE REVIEW: STRUCTURE, CONDUCT, AND PERFORMANCE

Performance refers to the efficiency and effectiveness with which professional in-formation markets meet individual, organizational, and societal information needs. We focus on two important indicators for media performance, namely price and di-versity. *Price* is the monetary price that users pay for information products. *Diver-sity* is heterogeneity of information supply in terms of sector-specific content crite-ria. Diversity exists as a combination of *internal diversity*, defined as heterogeneity of content within information services, and *external diversity*, defined as heteroge-neity of content between information services. (McQuail & Van Cuilenburg, 1983; Van der Wurff, Van Cuilenburg, & Keune, 2000).

Prices and diversity together indicate what information is effectively available to users. Professionals generally perform better when they have access to a wider variety of information products. Performance thus increases when prices decline and/or diversity increases. More specifically, internal diversity confronts users with a wide range of views, norms, and ideas, and is generally appreciated from a societal perspective. External diversity in contrast is appreciated from an individ-ual perspective because it enables users to choose between clearly defined prod-ucts. Neither type of diversity can *a priori* be preferred. Hence, performance is higher when internal and external diversity are better balanced.

Market Conduct

Performance is the outcome of market conduct, the interactive strategic behavior of competing providers. Providers basically choose between two different strategies: a *low-cost* or *lowest common denominator* strategy and a *product differentiation* strategy. Providers that adopt a lowest common denominator strategy compete on price. They target one "broad but shallow" (Chae & Flores, 1998, p. 43) market with one popular product. They realize significant economies of scale and produce

at lower costs than their competitors do. Providers that adopt a product differentiation strategy, in contrast, compete on content (quality). They target one or more "narrow but deep" (Chae & Flores, p. 43) market(s) with specialized products. They face higher first copy costs, but also price discriminate between users and charge (higher) prices that better reflect users' willingness to pay (Porter, 1980; Tirole, 1988).

Different combinations of strategies produce different types of market conduct and performance (Hotelling, 1929; Tirole, 1988; Van Cuilenburg, 1999; Van der Wurff & Van Cuilenburg, 2001). When most providers adopt lowest common denominator strategies, *ruinous price competition* emerges. Competition forces prices down to marginal cost levels. Revenues are insufficient to finance high first copy costs of information products. Providers consequently cut down on product development, and information supply becomes excessively the same, both internally and externally. In contrast, when most providers adopt product differentiation strategies, *weak competition* emerges. Providers segment the market, acquire market power, raise prices, and use resulting revenues to finance product differentiation. Information supply consequently is externally diverse. Most advantageous for users, however, is *moderate competition*. Moderate competition emerges when some information providers adopt product differentiation strategies and (one or a few) others adopt low-cost strategies. Umbrella competition (Picard, 1989) between these providers prevents both product differentiators from charging excessive prices (as in weak competition) and low-cost players from offering unacceptable low quality and diversity (as in ruinous competition). The resulting information supply is both externally and internally diverse, and moderately priced.

Market structure

Market structure determines the likelihood that providers will adopt particular strategies and thus that moderate competition will appear. Product differentiation generally is the preferred strategy for competing providers. Yet, in some market situations, low-cost strategies become more attractive (Tirole, 1988).

First, when an outside force (such as a regulator) sets prices, providers have nothing to fear from price competition nor anything to gain from product differentiation. In this situation, their preferred strategy rather is to increase market share by adopting lowest common denominator strategies. As a result, providers equally share the market and provide excessive sameness (Hotelling, 1929; Tirole, 1988). This situation is likely to occur on attention markets where information prices by definition are set to zero. For example, we find that there is less product differentiation and more lowest common denominator programming on advertising-funded than on pay TV markets (Brown, 1996; Chae & Flores, 1998; Doyle, 1998; Owen & Wildman, 1992).

Second, and more tentatively, we expect that information providers tend toward lowest common denominator strategies to prevent advertising price competition as well. After all, providers of lowest common denominator information products share audience markets and thus in principle offer advertisers access to *different* parts of the main audience. Providers of differentiated information products, in contrast, reach and offer access to *similar* audiences—to the extent that professionals acquire multiple need-to-know information products. In other words, providers of differentiated information products tend to offer substitutes to advertisers. They therefore compete more strongly on advertising price than do providers of similar information products.[1] This argument, as well as the previous one, lead us to conclude that product differentiation is more attractive on professional information markets, whereas lowest common denominator strategies are more attractive on professional attention markets.

Assuming that lowest common denominator providers share the main audience, low-cost strategies are also more attractive when the number of information providers is smaller and proportional shares of the main audience are consequently larger, and/or when preferences are less uniformly distributed and nonmainstream audience segments consequently are smaller. Preferences may even be so unevenly distributed that market segments become too small to finance first copy costs of targeted products, and product differentiation is prohibited (Beebe, 1977; Owen & Wildman, 1992). In addition, the likelihood that a *single* provider in any situation adopts a lowest common denominator strategy depends on the strategic choices of its competitors. The more competitors adopt differentiation strategies, the more attractive lowest common denominator strategies become, and vice versa (cf. Porter, 1980).

Providers' strategic choices finally depend on their position in the information value chain. Publishers increasingly compete with original content producers and advertisers that bypass publishers and distribute information directly to professionals. This process of disintermediation (Sarkar, Butler, & Steinfield, 1995; Steinfield, Kraut, & Plummer, 1995) eliminates the value that publishers traditionally add. On disintermediated markets, publishers no longer select and check information, create audiences, and spread the costs over many different users. New, nontraditional information providers have to develop their strategies accordingly. They need to find new ways to finance audience creation, while at the same time they must ensure that aggregated information and selection costs for users do not increase. In practice,

[1]See Picard (1989) for a brief discussion of intermedia substitution on information and attention markets. Of course, information providers also differentiate information products in an attempt to offer differentiated audiences to advertisers. Technological change even increasingly enables them to do so (Koschat & Putsis, 2002). Nevertheless, as long as professionals read multiple journals, differentiation products are to some extent substitutes for advertisers, and product differentiation hence makes more sense on information than on attention markets.

only content producers and attention-seekers that provide specific information to specific audiences for marketing, public relations, research, or educational purposes can accomplish this goal (Van der Wurff, 2001). Only they can provide targeted, low-priced or free information that can compete with more comprehensive and expensive offerings of traditional publishers. In strategic terms, this implies that disintermediation involves new entry of nontraditional providers that adopt a mix of *focused* low-cost and differentiation strategies (Porter, 1980).

Hypotheses

Professional information market conduct thus depends on the number (or concentration) of information providers, on the balance between information and attention markets, and on the extent of disintermediation.

When the number of providers is low and the market is concentrated, providers have ample opportunities and incentives to differentiate products. Markets therefore are segmented, and competition is weak. Building upon the United States' 1982 merger guidelines (in Scherer & Ross, 1990), we predict that such a situation emerges when the Herfindahl–Hirschmann Index (HHI) for market concentration is higher than 0.18. When more providers operate on a market and the market is thus only moderately concentrated (that is, when $0.10 \leq HHI \leq 0.18$), market segments are smaller and less attractive while the threat of price competition on attention markets is stronger. A few providers therefore adopt low cost strategies, and competition is moderate. Finally, when the market is not concentrated (HHI < 0.10), players necessarily compete within market segments. They adopt low cost strategies, and competition is ruinous.

Because product differentiation is more attractive on information than on attention markets, a market in which more providers depend to a larger extent on subscription revenues more likely shows weak competition. According to Dutch professional information publishers, 30% subscription income is a minimum for stable exploitation of a trade journal (Van der Wurff, Bakker, Van Cuilenburg, & Hellenberg, 1999). Following this lead, we predict that the thresholds between weak and moderate competition and between moderate and ruinous competition lie at 70% and 30% subscription revenue, respectively.

Both arguments together lead to the first hypothesis:

H1: TC = f(MC, IM)

where TC is type of competition (weak, moderate, ruinous), MC is market concentration (high, when HHI > 0.18; moderate; or low, when HHI < 0.10), and IM is the relative size of the information market (large, when subscription income/total revenues > 70%; medium; or small, when subscription income/total revenues < 30%).

Under conditions of weak competition, *incremental* changes in market structural characteristics that in principle could intensify (price) competition but not yet force the shift to moderate competition are to a large extent absorbed by market segmentation. Likewise, under moderately competitive conditions, incremental changes in concentration or information market size primarily result in corresponding changes in umbrella competition. It is only under conditions of ruinous competition that structural changes directly influence the intensity of (price) competition within market segments. The following is hypothesized.

If TC = weak,

H2: MS = Z_1 (+MD, +IM)
H3: UC = Z_2 (+MD, −IM)
H4: CI = Z_3 (+MD, −IM)

If TC = moderate,

H2: MS = Z_4 (−MD, +IM)
H3: UC = Z_5 (+MD, −IM)
H4: CI = Z_6 (+MD, −IM)

If TC = ruinous,

H2: MS = Z_7 (−MD, +IM)
H3: UC = Z_8 (−MD, +IM)
H4: CI = Z_9 (+MD, −IM)

where MD is market deconcentration (the inverse of MC, market concentration), MS is market segmentation, UC is umbrella competition, and CI is competition intensity in market segments; where Z_2, Z_3, Z_4, Z_6, Z_7, and Z_8 approach 0; and where Z_1, Z_5, and Z_9 approach 1.

Performance follows from market conduct. Market segmentation, as a first element of market conduct, creates market power and causes high information prices. It also contributes positively to external and total diversity, and negatively to internal diversity. Second, umbrella competition limits market power. It reduces information prices and contributes to internal and total diversity, while slightly reducing external diversity. Third, competition within market segments is accompanied by low cost strategies. It destroys market power, minimizes prices, and reduces internal, external, and total diversity to excessive sameness.

Disintermediation finally affects performance because it results in market entry of nontraditional providers. These nontraditional providers distribute specific information, which used to be part of more comprehensive products supplied by tra-

ditional publishers, as separate products at very low information prices. Hence, disintermediation results in a decline of information prices and internal diversity, and an increase in external diversity, without significantly affecting aggregate diversity. We hypothesise:

H5: $P = f(+MS, -UC, -CI, -DIM)$, where P is price and DIM is disintermediation

H6: $D = f(+MS, +UC, -CI)$, where D is aggregate diversity

H7: $ID = f(-MS, +UC, -CI, -DIM)$, where ID is internal diversity

H8: $ED = f(+MS, -UC, -CI, +DIM)$, where ED is external diversity

METHOD: A CASE STUDY OF AGRICULTURAL JOURNALS

We tested the model using data on the Dutch agricultural trade journal market for the years 1991 to 2000. Such a limited test was warranted given the preliminary nature of the model and the resource problems involved in collecting and comparing price and diversity data for more than one market. A single market study, however, brings its own particular problems. Most important, it is not likely that any single professional information market shows sufficient variation in structural and conduct variables to test the model completely. We therefore needed to make additional assumptions and specify the model accordingly.

Taking these considerations into account, the Dutch market for agricultural trade journals offers an interesting case. It is part of a wider, internationally renowned agricultural information sector that has been seriously reorganized and commercialized in the last decade (Vergouwen, 1992). It serves the changing information needs of farmers who themselves try to adapt to new competitive relations and changing societal demands (Bijman, Van Tulder & Van Vliet, 1997; Leeuwis, 2000; Meulenberg, 1995). And it has become more concentrated, raising fears that diverse individual and societal information needs are not sufficiently met (J. Proost, personal communication, March 12, 2001).

The Market: Definitions and Sources

For the purposes of this study, a Dutch agricultural trade journal was defined as a print publication in the Dutch language that appears at regular intervals 4 to 52 times a year and that provides information relevant to professional farming activities. Traditional providers of these journals were commercial publishers and publishers associated with farmers organizations. Original content producers were primarily research organizations. And attention-seekers were agricultural suppliers and traders.

Electronic editions of the *Trade Book of Press and Publicity in The Netherlands* (Redactie, 1991–2000) provided information on the number of titles, target groups, publishers, frequencies, and subscription and advertising prices. The *Dutch Central Catalogue of Publications* (PICA, 2001) provided additional information on the number of titles. The Dutch business information database *Reach* (Bureau van Dijk-Electronic Publishing, 2001) provided information on key activities of information providers. Agricultural background data came from the Dutch Agricultural Economic Institute (Landbouw Economisch Instituut, 2001) and the Dutch Statistical Agency (Centraal Bureau voor de Statisiek, 2001). A quantitative content analysis provided information on heterogeneity of information supply.

Research Design

The HHI for concentration in the agricultural journal market varied between 0.10 to 0.14. Following hypothesis 1, this implies that competition was moderate. Data on advertising revenues was lacking, so precise sizes of information and attention markets was unclear. However, Dutch professional publishing in general depends on subscriptions for 60% of its income and on advertising for the remaining 40% (Media Group, 2000). More specifically, three publishers of major agricultural trade journals estimated, respectively, a 60–40, 50–50, and 30–70 split between subscription and advertising revenues for the agricultural trade journal market (Personal communications, July 22, 23, & 24, 2002). Following hypothesis 1, these data suggest once more that competition was moderate.

Moderate competition is characterized by strong umbrella competition and market segmentation. We defined a market segment as consisting of one or more journals that inform farmers on one or several of the particular clusters of farming activities that are identified by Dutch agricultural and statistical organizations. We then found that the Dutch market for agricultural journals encompasses 34 market segments. Some are very specific, include only one title, and reach as few as 900 readers. Others are general, include up to 10 titles, and can reach as many as 120,000 readers. Market conduct thus fits the description of moderate competition. We conclude for the time being that hypothesis 1 is supported by the (limited) data that we have and specify hypotheses 2 through 4 accordingly.

We tested hypotheses 2 through 8 with regression analysis. The test was divided into six parts. Parts 1 to 3 included all journals mentioned in the Trade Book (Redactie, 1991–2000) and focused on the impact of structure and conduct on price only. Parts 4 to 6 studied the impact on diversity as well. To keep content analysis manageable, parts 4 to 6 included only the journals that are available at the Royal Library, that are mentioned as agricultural publications in the Trade Book (Redactie) or the Central Catalogue (PICA, 2001), and that target one of six spe-

cific groups of farmers.[2] In addition, we limited the analysis to the odd years in the period from 1991 to 2000.

Parts 1 and 4 focused more specifically on the overall market. Parts 2 and 5 focused on individual market segments. Parts 3 and 6, finally, focused on those market segments that make up a *user market*—a market that encompasses all general and specific market segments that cater to the particular needs of a particular user group.[3]

Variables

We included three sets of variables, for structure, conduct, and performance, respectively. These variables were defined at the market (segment) level but required measurements at the level of individual titles. We weighted these measurements for circulation or title numbers to arrive at estimates of structural market (segment) variables.[4] For conduct and performance variables, on the other hand, we used nonweighted estimates because we were interested in (the implications of) suppliers' conduct, not in (the consequences of) users' buying decisions.

Market deconcentration (MD) was defined as the inverse of the HHI for the market.[5] Disintermediation (DIM) was measured as the aggregated market share of nontraditional providers (i.e., previous content producers and attention-seekers that now provide their own journal). Information market size (IM), as the third structural variable, was measured as the relation between the ranking of a journal in terms of subscription revenues (defined as subscription price multiplied by circulation) and its ranking in terms of *approximated* advertising revenues (defined as advertising price for a one-page add multiplied by publication frequency). Prices were corrected for inflation. A score approaching 1 implies that a journal is

[2]These are dairy farmers, cattle breeders, and pig breeders in the provinces of Gelderland and Noord-Brabant, arguably the most important farmer groups in The Netherlands. We limited the content analysis to journals that reach a sizeable share of these target groups, that is, 10% of dairy, meat cattle, or pig farmers; 15% of livestock farmers; 20% of farmers in Gelderland or Noord-Brabant; or 33% of all Dutch farmers.

[3]Farmers receive on average six different journals, including at least one general national and one regional agricultural journal, and one or more trade-specific journals (Vergouwen, 1992; J. Proost, personal communication, March 12, 2001). The user market for dairy farmers, for example, includes market segments that provide information on (a) general agriculture, (b) livestock and arable farming, (c) livestock farming, (d) pastured livestock farming, (e) cattle farming, and (f) dairy farming.

[4]We used circulation numbers as the weighting factor, except for user markets, for which we used the number of titles because circulation numbers are not comparable across general and specific market segments.

[5]$HHI = \Sigma m_i^2$ where m_i is the share of publisher i in circulation numbers, or for user markets, in the number of titles. Unfortunately, market deconcentration cannot be measured in a meaningful way for individual market segments.

ranked very high in terms of subscription income and very low in terms of approximated advertising income. Journals without advertising and/or published by original content producers were considered as 100% information market journals (receiving a score of 1); journals provided by attention-seekers were considered as 100% attention market journals (receiving a score of 0). The variable IM was the weighted, or (for parts 3 and 6) nonweighted, average score of all relevant journals.[6]

The conduct variable market segmentation was measured as its inverse (iMS), which was defined as average circulation per market segment. To assess umbrella competition (UC), we grouped market segments in six layers of increasing specificity. For the overall market and for user markets (parts 1, 3, 4, and 6), we measured UC as the standard deviation of circulation numbers across layers. An increase in standard deviation in practice implies that general market segments have become larger and therefore signals an intensification of umbrella competition. For individual market segments (parts 2 and 5), we measured UC as the ratio of total circulation in encompassing segments to circulation in the segment under investigation. Competition intensity (CI) was defined as the inverse of the (average) HHI for titles per market segment.

The dependent variable price was a nonweighted average of relevant journal subscription prices. Prices were corrected for general changes in the producers' price index for domestic publishers (Centraal Bureau voor de Statistiek, 2001). Diversity, finally, was measured via content analysis. We classified all articles in selected issues and counted the number of pages (in units of quarter A4 pages) that each issue devoted to 20 agricultural information categories. These categories encompassed the range of topics on which farmers need to be informed (e.g., market information, cultivation advice, management information) as well as the range of perspectives from which these topics can be discussed (i.e., ecological, modern quality-oriented, and traditional growth-oriented perspectives), and included a category not classified elsewhere.[7] Re-

[6]For journals included in parts 4 to 6, we had more information and estimated the ratio of subscription revenues (circulation × subscription price) to total revenues (subscription + advertising revenues, where advertising revenues = annual number of add pages × price for a one-page add). Correlation between this ratio and the one for individual journals discussed in the main text was .808 ($p < .001$). Variable IM, therefore, offers an adequate indicator for information market size.

[7]We selected the first one or two issues (of journals appearing up to 12 times annually and of journals appearing more than 12 times annually, respectively) for May (which is a busy month for farmers) and November (which is a relatively quiet month), disregarding special issues. When issues were not available, we used appropriate substitutes. The information categories were derived from a review of relevant articles from the annual policy outlooks of the Ministry of Agriculture, and an interview with an expert in agricultural information. To estimate intracoder reliability, articles in 24 issues, equally spread over type of journals and years, were coded twice. Results suggest that coding is reliable. In 444 out of 480 cases (92.5%), same categories were found to be present (or not) in issues. Per issue, correspondence ranged between 85% and 100%. Because different classifications of articles also resulted in different estimates of the number of pages per category, we correlated codings. Per issue, correlations ranged between 0.971 and 1 ($p < .001$). Correlation between both complete codings was 0.994 ($p < .001$).

sults were multiplied by the frequency and average page size of the journal to estimate annual contribution per journal to total information supply. We then used the entropy measure,[8] as suggested by McQuail and Van Cuilenburg (1983), to estimate heterogeneity of total information supply (total diversity) and average heterogeneity of information supply within individual journals (internal diversity). External diversity, finally, was defined and measured as the difference between total and internal diversity.

RESULTS

From 1991 to 2000, the Dutch market for agricultural trade journals counted an average of 73.5 journals per year. Circulation averaged 1.1 million copies. The number of providers declined from 53 to 40 and concentration increased (HHI = 0.10 in 1991, 0.14 in 1995 and 1996, 0.13 in 2000). Market shares of nontraditional providers varied between 18% (1991), 14% (1996), and 20% (2000). Information market size strongly fluctuated while declining slowly. Market segmentation increased, umbrella competition declined, and competition intensity first declined (until 1997) and then increased again. Lastly, prices increased, reaching maximal levels in 1993 and 2000.

Market segments that provided journals to six selected groups of farmers encompassed 8 providers, 10 titles, and 480,000 copies in 1991; and 12 providers, 24 titles, and 642,000 copies in 1999. Market shares of nontraditional providers were low until 1995 (13%) and much higher thereafter (28% in 1997, 26% in 1999). Prices fluctuated, and diversity and external diversity increased, while internal diversity remained more or less stable.

Regression Results

Table 1 presents significant results from regression analysis.[9] A first conclusion can be that different predicted relations can be observed in different but not in all parts of the analysis. Because we studied only one market with a limited number of cases, we do not directly conclude from this lack of support that hypotheses are fal-

[8]Total diversity $= -\Sigma (p_i \times {}^n\log[p_i])$ where p_i is the relative number of pages in all journals in the market per information category i, and n is the number of information categories (20). Internal diversity in the market is equal to average internal diversity per journal, where internal diversity per journal is calculated in the same way as total diversity, and p_i stands for the relative number of pages *per journal* per category i.

[9]We included all variables stepwise in regression analysis. For parts 1 to 3, variables were entered when $F < .05$ and removed when $F > .10$. For parts 4 to 6, in which we had fewer cases, we used less stringent rules: entry of variables when $F < .10$, removal when $F > .20$.

TABLE 1
Regression Results Per Part

Part	Significant Beta Coefficients	R^2, N
1	$MS_m = —$	
	$UC_m = \alpha + .665^* MD_m$	$R^2 = .442, N = 10$
	$CI_m = —$	
	$P_m = \alpha - .826^{**} UC_m$	$R^2 = .683, N = 10$
2	$MS_{ms} = —$	
	$UC_{ms} = \alpha + \mathbf{.145^* IM_{ms}}$	$R^2 = .021, N = 295$
	$CI_{ms} = \alpha - .296^{***} IM_{ms}$	$R^2 = .087, N = 295$
	$P_{ms} = \alpha - .292^{***} DIM_{ms} + .117^* MS_{ms} - .111^* UC_m$	$R^2 = .116, N = 309$
3	$MS_{mu} = \alpha - .454^{***} MD_m - .488^{***} MD_{mu} + .247^{**} IM_{mu}$	$R^2 = .429, N = 170$
	$UC_{mu} = \alpha + .532^{***} MD_m - .374^{***} IM_{mu} + .174^* MD_{mu}$	$R^2 = .367, N = 170$
	$CI_{mu} = \alpha + .406^{***} MD_m + .318^{***} MD_{mu}$	$R^2 = .314, N = 170$
	$P_{mu} = \alpha + .674^{***} MS_{mu} - .245^{***} DIM_{mu}$	$R^2 = .427, N = 170$
4	$MS_{6m} = \alpha - .986^{**} MD_m$	$R^2 = .972, N = 5$
	$UC_{6m} = —$	
	$CI_{6m} = —$	
	$P_{6m} = \alpha - .871° UC_m$	$R^2 = .759, N = 5$
	$D_{6m} = \alpha + .963^{**} MS_{6m}$	$R^2 = .927, N = 5$
	$ID_{6m} = \alpha - \mathbf{.855° UC_{6m}}$	$R^2 = .731, N = 5$
	$ED_{6m} = \alpha - .977^{**} UC_m$	$R^2 = .955, N = 5$
5	$MS_{6s} = —$	
	$UC_{6s} = —$	
	$CI_{6s} = —$	
	$P_{6s} = \alpha - \mathbf{.777^{***} MS_{6s}} + \mathbf{.511^{***} UC_{6s}} - .260^* UC_m - .290^* DIM_{6s}$	$R^2 = .536, N = 39$
	$D_{6s} = \alpha + \mathbf{.682^{**} CI_{6s}} + .570^{**} MS_{6s}$	$R^2 = .252, N = 39$
	$ID_{6s} = —$	
	$ED_{6s} = \alpha + \mathbf{.768^{***} CI_{6s}} + .404^{**} MS_{6s} + .376^{**} DIM_{6s}$	$R^2 = .693, N = 39$
6	$MS_{6u} = \alpha - .759^{***} MD_m$	$R^2 = .576, N = 30$
	$UC_{6u} = \alpha + \mathbf{.715^{***} IM_m} + .536^{***} MD_m - \mathbf{.244^{**} MD_{6u}}$	$R^2 = .878, N = 30$
	$CI_{6u} = \alpha - .550^{**} IM_m$	$R^2 = .303, N = 30$
	$P_{6u} = \alpha - .874^{***} UC_m$	$R^2 = .764, N = 30$
	$D_{6u} = \alpha + 1.024^{***} MS_{6u} + \mathbf{.870^{***} CI_{6u}} + .324^{***} UC_{6u} - \mathbf{.105^* DIM_{6u}}$	$R^2 = .953, N = 30$
	$ID_{6u} = \alpha + \mathbf{1.340^{***} MS_{6u}} + \mathbf{.796^{***} CI_{6u}} + .485^{**} UC_m + .357° UC_{6u}$	$R^2 = .727, N = 30$
	$ED_{6u} = \alpha - .970^{***} UC_m - \mathbf{.563^* MS_{6u}}$	$R^2 = .607, N = 30$

Note. Betas for MS are inverses of betas for iMS, because iMS was included in regression analysis. Items bold indicate findings that contradict the model. P = price; D = diversity; ID = internal diversity; ED = extern diversity; MS = market segmentation; UC = umbrella competition; CI = competition intensity; MD = mark deconcentration; IM = information market size; DIM = disintermediation; m = agricultural journal market; ms agricultural journal market segment; mu = agricultural journal user market; 6m = market consisting of tho segments that serve six selected user groups; 6s = individual segment that serves one or more of those user group 6u = user market defined from the perspective of one of those user groups.

$°p < .1.$ $^*p < .05.$ $^{**}p < .01.$ $^{***}p < .001.$

sified. Rather, we consider only those hypotheses falsified that are confirmed in neither part of the analysis.

Table 1 provides particular support for hypothesis 5. Prices depended negatively on umbrella competition (in parts 1, 2, 4 and 6 of the study) and on disintermediation (parts 2, 3, and 5). Prices also depended positively on market segmentation (parts 2 and 3). Only in part 5, in which we focused on specific segments that serve particular needs of six selected user groups, were prices related negatively to market segmentation and positively to umbrella competition. In all, we conclude that hypothesis 5 is confirmed, with the notable exception that in no part did prices depend (negatively) on competition intensity (see Table 2).

Market segmentation depended, more strongly than predicted, negatively on market deconcentration (parts 3, 4, and 6) and positively on information market size (part 3). Competition intensity depended, again more strongly than predicted, positively on market deconcentration (part 3) and negatively on information market size (parts 2 and 6). Umbrella competition, finally, depended positively on market deconcentration (parts 1, 3, and 6), with the exception of the small negative relation between umbrella competition and market deconcentration on selected user markets (part 6). We interpret these results as support for hypotheses 2 to 4, even though effects were much stronger than predicted. This is because part 1 clearly confirms that market deconcentration primarily translates into umbrella competition in the overall market. The other effects, found in parts 2 through 5, therefore, merely show that structural variables cause variation in conduct across different segments in the direction that is predicted by the model. Only the positive relation between umbrella competition and information market size (compare parts 2 and 6 with part 3) contradicts predictions.

Less support can be found for hypotheses 6 to 8. Diversity, as stated in hypothesis 6, depended positively on market segmentation and umbrella competition (parts 4, 5, and 6). However, diversity also depended to some extent negatively on disinter-

TABLE 2
Aggregate Results From Regression Analysis and Their Implications for Hypotheses

Result	Confirms, Rejects, or Both	Hypothesis
MS = – MD, + IM	C – C	2
UC = + MD, ± IM	C – B	3
CI = + MD, – IM	C – C	4
P = + MS, – UC, – DIM; P ≠ CI	C – C – C – R	5
D = + MS, + UC, + CI, – DIM	C – C – R – R	6
ID = + MS, ± UC, + CI; ID ≠ DIM	R – B – R – R	7
ED = ± MS, – UC, + CI, + DIM	B – C – R – C	8

Note. MS = market segmentation; MD = market deconcentration; IM = information market size; C = confirm; UC = umbrella competition; B = both; CI = competition intensity; P = price; DIM = disintermediation; R = reject; D = diversity; ID = internal diversity; ED = external diversity.

mediation (part 6) and positively on competition intensity (parts 5 and 6). Especially this latter result strikingly contradicts predictions. Hypothesis 7 is even less supported. Internal diversity depended both negatively and positively on umbrella competition (parts 4 and 6), positively on market segmentation (part 6), and positively on competition intensity (part 6). These are again strikingly contradictory results. Lastly, external diversity[10] depended as predicted negatively on umbrella competition (parts 4 and 6) and positively on disintermediation (part 5). Like other diversity indicators, external diversity also depended positively on competition intensity (part 5). Finally, results show that external diversity depended both positively and negatively on market segmentation (parts 5 and 6).

DISCUSSION AND CONCLUSION

Comparing the model and results, several contradictions emerge. The first concerns disintermediation. Results show that disintermediation increases external diversity at the level of individual market segments (part 5), as predicted. Yet results also show an unpredicted (small) negative effect of disintermediation on aggregate diversity (in part 6). More importantly, results do not support the prediction that disintermediation negatively affects internal diversity. In sum, the overall impact of disintermediation on diversity is more complicated than was predicted. An explanation might be that the model does not take strategic responses of traditional publishers to disintermediation into account. Additional research is necessary to further investigate this issue.

A second problem concerns umbrella competition. Results show that umbrella competition depends both positively and, to a lesser extent, negatively on information market size (compare parts 2 and 6 with part 3). These results suggest that umbrella competition not only involves a balancing act between low-cost and product differentiation strategies, as defined in the model, but also requires an appropriate balance between information and attention market sizes. That would explain that either a relatively "too large" or "too small" information market reduces umbrella competition.

The third and most serious question arises from the established positive relations between competition intensity and diversity. Results very clearly indicate that intensity of competition within selected market segments is positively related

[10]We first included all variables in regression analysis of external diversity in part 6. We then found that $ED = \alpha + 1.522^{***} MS_m - 1.123^{***} DIM_m - 0.557^{**} MS_{6u}$. However, the strong negative impact of disintermediation of the overall market DIM_m on external diversity in selected market segments did not make much sense from a theoretical point of view, especially not when we took into account that disintermediation of selected market segments did contribute positively to external diversity (part 5). We therefore excluded DIM_m from analysis and ran a second regression, the results of which are presented in the text and Table 1.

to internal, external, and total diversity. Looking more closely into these segments, we find that they are very concentrated. In 18 out of 39 cases, segments include only one title; and in no case does the HHI for titles' market shares pass below the 0.18 threshold that we consider, at the market level, to be the threshold for moderate competition. In sum, there is a lack of competition in individual market segments; and results indicate that this negatively affects diversity. Prices, in contrast, are not affected by the lack of competition in market segments. Rather, they depend on competitive pressures in the overall market. The important implication that follows from these results is that we need to analyze relations between competition and (a) prices and (b) diversity at different levels. An intuitive explanation for this finding might be that prices follow from strategic decisions of publishing companies' general management based on inputs, human resources, and (re)production technology, whereas editorial policy is the realm of publishers that are responsible for individual titles.[11]

Finally, we emphasize that conclusions on the impact of structure on conduct hold only under the assumption that conditions on the agricultural trade journal market indeed support moderate competition. The analysis in no way contradicts this assumption, yet more research on other markets is necessary to further substantiate this claim.

FINAL CONCLUSIONS: COMPETITION, PRICES, AND DIVERSITY

In spite of these concerns, we also find strong support for the model. We predicted that structural changes under moderate competition translate first of all to changes in umbrella competition, and we find indeed that market deconcentration strengthens umbrella competition and, subsequently, that umbrella competition is the prime determinant of prices in the overall market. Further analysis of market segments confirms that prices are additionally influenced by market segmentation and disintermediation.

We also predicted that market segmentation and resulting competition within and between market segments determine diversity in its various dimensions. Results partly confirm this argument. They show in particular that market segmentation and umbrella competition increase total diversity and that umbrella competition reduces external diversity. Results additionally show that competition between titles in market segments can become so low that diversity is negatively affected. In other words, both too little and too much market segmentation (which leads to monopolistic mar-

[11]See Iossifov (2001) for a description of such a division of responsibilities within Dutch newspaper companies.

ket segments) turn out to negatively affect diversity. These findings complement and elaborate the model rather than falsify it.

We conclude that market segmentation, umbrella competition, and competition within market segments depend on market deconcentration and information market size. Prices depend on market segmentation and, in particular, on resulting (umbrella) competition between market segments, but not on competition within market segments—at least, not as long as competition in market segments is nonexistent or weak. Diversity depends on market segmentation and, in particular, on resulting competition within market segments—whereby both too weak and (at least theoretically) also too strong competition reduce diversity.

These results explain why agricultural information specialists worry about the negative impact of perceived monopolization of market segments on information content, although the market itself is competitive (at the overall level). They challenge (media) economists and communication scholars to investigate whether in other media industries (newspapers, broadcasting, general interest magazines) prices and diversity likewise are determined at different market levels. And they suggest that competition and media policy makers who want to address pricing and diversity issues need to distinguish clearly between relevant markets that determine prices and diversity, respectively.

ACKNOWLEDGEMENTS

I thank Jan van Cuilenburg, Edmund Lauf, Ilja van Beest, Angela van der Lee, and two anonymous reviewers for their useful comments on earlier drafts; Silvia van Staveren of Nijgh Publishers for helping to obtain previous versions of the Nijgh Media Disc; Jet Proost of Wageningen University for giving a very useful introduction in agricultural information; and various publishers for providing information on their agricultural trade journals. Of course, any remaining errors are only my responsibility.

REFERENCES

Beebe, J. H. (1977). Institutional structure and program choices in television markets. *The Quarterly Journal of Economics, 91*, 15–37.

Bijman, W. J. J., Van Tulder, R. J. M., & Van Vliet, L. M. (1997). *Agribusiness, R&D en internationalisatie: Internationaliseringsstrategieën van agro-ondernemingen en de betekenis voor het eigen kennismanagement* [Agrobusiness, R&D and internationalization: Internationalization strategies and implications for knowledge management]. (NRLO Rep. No. 97/12). The Hague, The Netherlands: National Council for Agricultural Research.

Brown, A. (1996). Economics, public service broadcasting, and social values. *The Journal of Media Economics, 9*(1), 3–15.

Bureau van Dijk-Electronic Publishing (2001). *Reach* [Financial database on Dutch companies]. Database accessed on March 31, 2001 and May 27, 2001 from http://www.bvdep.com/ProductPage.asp?product=REACH.

Centraal Bureau voor de Statistiek (2001). *Statline* [Electronic databank of Statistics Netherlands]. Database accessed on January 19 and 22, 2001 and May 30, 2001 from http://www.cbs.nl/en/figures/statline/index.htm.

Chae, S., & Flores, D. (1998). Broadcasting versus narrowcasting. *Information Economics and Policy, 10*, 41–57.

Doyle, C. (1998). Programming in a competitive broadcasting market: Entry, welfare and regulation. *Information Economics and Policy, 10*, 23–39.

Hotelling, H. (1929). Stability in economic competition. *Economic Journal, 39*(153), 41–57.

Iossifov, I. (2001). *The market for national newspapers in The Netherlands: Competitive structure and innovation practices.* Unpublished manuscript, The Amsterdam School of Communications Research ASCoR, The Netherlands.

Koschat, M. A., & Putsis, W. P. (2002). Audience characteristics and bundling: A hedonic analysis of magazine advertising rates. *Journal of Marketing Research, 39*, 262–273.

Leeuwis, C. (2000). Learning to be sustainable: Does the Dutch agrarian knowledge market fail? *Journal of Agricultural Education and Extension, 7*, 79–92.

Landbouw Economisch Instituut (2001). *Binternet* [Electronic database of the Dutch Agricultural Economic Institute]. Database accessed on January 19 and 22, 2001 from http://www.lei.dlo.nl/lei_engels/HTML/statistics/statistics.html.

McQuail, D., & Van Cuilenburg, J. (1983). Diversity as a media policy goal. *Gazette, 31*, 145–162.

Media Group (2000). *Competitiveness of the European Union publishing industries.* Brussels, Belgium: European Commission.

Meulenberg, M. T. G. (1995). Evolutie van marketing en marketing-informatie in landbouw en agribusiness [Development of marketing and marketing-information in agriculture and agrobusiness]. *Agro Informatica, 8*(2), 10–15.

Owen, B. M., & Wildman, S. S. (1992). *Video economics.* Cambridge, MA: Harvard University Press.

PICA (2001). *Nederlandse Centrale Catalogus* [Dutch Central Catalogue of Publications]. Database accessed on March 26, 2001 from http://picarta.pica.nl/LNG=NE/DB=2.4/.

Picard, R. G. (1989). *Media economics.* Newbury Park, CA: Sage.

Porter, M. (1980). *Competitive strategy.* New York: Free Press.

Redactie (1991–2000). *Handboek van de Nederlandse Pers en Publiciteit* [Trade Book of Press and Publicity in The Netherlands; electronic version]. Schiedam, The Netherlands: Nijgh Periodieken.

Sarkar, M. B., Butler, B., & Steinfield, C. (1995). Intermediaries and cybermediairies. *Journal of Computer-Mediated Communication, 1*(3). Retrieved April 6, 1999 from http://www.ascusc.org/jcmc/vol1/issue3/sarkar.html.

Scherer, F. M., & Ross, D. (1990). *Industrial market structure and economic performance* (3rd ed.). Boston: Houghton Mifflin.

Steinfield, C., Kraut, R., & Plummer, A. (1995). The impact of interorganizational networks on buyer-seller relationships. *Journal of Computer-Mediated Communication, 1*(3). Retrieved November 1, 1999 from http://www.ascusc.org/jcmc/vol1/issue3/steinfld.html.

Tirole, J. (1988). *The theory of industrial organization.* Cambridge, MA: MIT Press.

Van Cuilenburg, J. (1999). Between media monopoly and ruinous media competition. In Y. N. Zassoursky & E. Vartanova (Eds.), *Media, communications and the open society* (pp. 40–61). Moscow: Faculty of Journalism/IKAR Publisher.

Van der Wurff, R. (2001). Het nieuwe uitgeven: Content- en aandachts-markten in de nieuwe economie [The new publishing. Content and attention markets in the new economy]. *Tijdschrift voor Communicatiewetenschap 29*(1), 2–22.

Van der Wurff, R., Bakker, P., Van Cuilenburg, J., & Hellenberg, J. (1999). *De huidige en toekomstige markt voor vak en wetenschap* [The current and future market for trade and science] (Research Rep.). The Netherlands: The Amsterdam School of Communications Research ASCoR.

Van der Wurff, R., & Van Cuilenburg, J. (2001). The impact of moderate and ruinous competition on diversity: The Dutch television market. *Journal of Media Economics 14*, 213–229.

Van der Wurff, R., Van Cuilenburg, J., & Keune, G. (2000). Competition, media innovation and broadcasting. In J. Van Cuilenburg & R. Van der Wurff (Eds.), *Media and Open Societies* (pp. 119–157). Amsterdam: Het Spinhuis.

Vergouwen, M. (Ed.) (1992). *Kennis maken: Informatiestromen in agrarisch Nederland.* [Making knowledge: Information flows in Dutch agriculture]. Ede, The Netherlands: Informatie en Kennis Centrum Veehouderij.

JOURNAL OF MEDIA ECONOMICS, *16*(2), 139

CALL FOR PAPERS

6th World Media Economics Conference
"Revolution, Devolution, Evolution: Media Industry at Work"

Conference Venue: HEC Montreal, Canada (http://www.hec.ca)
Conference dates: May 12–15, 2004

The World Media Economics Conference brings together scholars of economic, financial, and management aspects of media and communication firms and interested professionals to consider contemporary problems and issues from business and social contents. The authors of accepted articles, or at least one of a coauthored article, must be present at the conference to make its presentation.

Submission deadline: October 15, 2003
Authors will be notified by December 15, 2003 regarding their submission. Final revisions are due by January 30, 2004.

Please send your article via e-mail in Microsoft Word attachment to: 6thwmec.papers.cem@ulaval.ca

You can also send *three hard copies* to: Centre d'études sur les mécias, Pavillon Casault, Local 5604, Université Laval, Quebec, Canada G1K 7P4.

The conference is sponsored by the Centre d'études sur les médias and the *Journal of Media Economics.*

For further information please visit the conference Web site at: http://www.cem.ulaval.ca/6thwmec

For Product Safety Concerns and Information please contact our EU
representative GPSR@taylorandfrancis.com
Taylor & Francis Verlag GmbH, Kaufingerstraße 24, 80331 München, Germany

www.ingramcontent.com/pod-product-compliance
Ingram Content Group UK Ltd.
Pitfield, Milton Keynes, MK11 3LW, UK
UKHW021609240425
457818UK00018B/460